IMAGES
of America

HARRISON

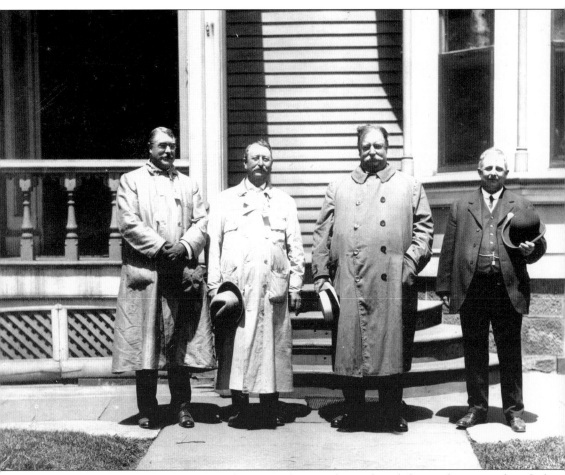

In front of the Davis mansion in this 1910 photograph are, from left to right, an unidentified bodyguard, an unidentified chauffeur, Pres. William Howard Taft, and William Davis. Taft visited Harrison on the campaign trail and was told by a councilman, "Why, we're alive with industries." The president misunderstood and, in a speech to town residents, said, "You have just reason to be proud of this Hive of Industry." The term stuck, and the slogan "Hive of Industry" is still used today.

IMAGES
of America

HARRISON

Ray and Karen A. Floriani

ARCADIA

First published 2003

Published by Arcadia Publishing,
an imprint of Tempus Publishing Inc.
Portsmouth NH, Charleston SC, Chicago,
San Francisco

Printed in Great Britain

Library of Congress Catalog Card Number: 2003110679

For all general information, contact Arcadia Publishing:
Telephone 843-853-2070
Fax 843-853-0044
E-mail sales@arcadiapublishing.com
For customer service and orders:
Toll-free 1-888-313-2665

Visit us on the Internet at www.arcadiapublishing.com

*Dedicated to Thomas and Ann Reilly and to family members
who called this special place home for many generations.
Also dedicated to Raymond A. and Lillian Floriani.*

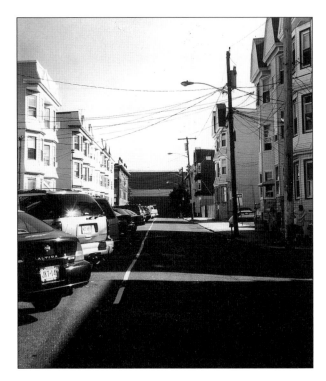

Seen is a recent view of Franklin Avenue. Although it has changed from the days when the Reilly family called this street and neighborhood home, the area still remains a sentimental and timeless place. (Photograph by Karen Floriani.)

CONTENTS

ACKNOWLEDGMENTS

We would like to thank Mayor Raymond McDonough and Ellen Lucas, the director of the library, who gave their whole-hearted blessing and cooperation with this project. We also want to mention the Harrison Library staff members who graciously aided us by making their wealth of resources available. The staff members include Linda Liquori, Catherine Martins, Pedro Matos, Virginia Matos, Kunal Mehra, Nelba Mejias, Kim Mullin, Joan Ostrowski, and Anne Walker. We also acknowledge the late town historian Henry Muntz, whose legacy was invaluable. We are also grateful to Anthony Comprelli, present town historian and assistant school superintendent, and O.J. DiSalvo, school superintendent and councilman, for their insight and support.

Thanks go to Harrison High School athletic director and girls basketball coach Jack Rodgers for his cooperation, outstanding support, and helping make the high school rescues available. Thanks to Councilman Michael Rodgers for his wealth of information on the town's history, specifically that of Mayor Frank Rodgers. Thanks to the Archdiocese of Newark; the Observer, Kearny, New Jersey; and Lee Frances Brown, who gave advice to get us started.

Thanks go to Harrison High School principal Ron Shields, girls soccer coach Tom Carney, cheerleading and tennis coach Nick Gregory, Bill Mullins, former assistant football coach Larry Manning, Fire Chief Tom Dolaghan, Councilman Art Pettigrew, and Harrison World Trade Center Monument Committee chairman James Woods.

Thanks to present and former Harrison residents Jim Pettigrew; Eddie Bagniewski; Jack and Marty Lawless; Lisa Villata; the entire Ferriero family, especially Donna Ferriero Oeckel; current Kearny High School girls basketball coach and former Harrison great Jodi Hill; and the staff at Max's Diner.

Our heartfelt appreciation to the late Thomas and Catherine Reilly, Thomas and Martha Murphy, and Ann Reilly, whose beloved memories remain in our hearts.

We express our sincere thanks and appreciation for your inspiration and encouragement to Thomas Reilly; Helen Weidele; Thomas Reilly Jr.; Patrick, Patricia, Tricia, Melissa, Patrick Jr., and Nina Purcell; Yvonne and John Albanese; Cheryl Reilly and John Buckheit; Robert and Jane Reilly; Joseph Reilly; and Albert and Lillian Kingeter.

We wish to acknowledge Raymond Floriani Sr. and the late Lillian Floriani for their inspiration and support. Also, thanks to Walt Floriani. Thanks to Ray's Eastern Basketball Magazine editors, including Ralph and Rita Pollio, the late Larry Donald, Mike Sheridan, David Scott, and present editor John Akers; valued colleagues George Rodecker and Dan Wetzel; Joe Dwyer of Collegeinsider.com; Valerie Ninemire at About.com; the "Trio" at Cusehoops.com; Clay Kallam at Fullcourt.com; and David Laibow of the Newark Review of Literature.

Thanks to Zygmunt Cichy for his help in time of need; Tom Penisch and his staff at Sir Speedy's in Lyndhurst; the late Prof. Peter Marron of St. Bonaventure University, a brilliant history lecturer in his day; Dr. William Eckert of St. Bonaventure, another outstanding expert on history; current St. Mary's High School (Rutherford) history department head Joan Van Loo, whose passion for the subject is infectious. Thanks also to Jersey Preparatory School administrators Mr. and Mrs. Ruiz for their support and understanding in this endeavor. Thanks to Ray's colleagues in writing and education, and to the School and College Officials Association (SCOA) and Board 33 basketball officials.

Finally, thanks to Sister Patricia Ann of St. Mary's, whose 1967 freshman English class instilled Ray with a love of writing.

INTRODUCTION

The official date of birth for Harrison as a township is noted as 1840. However, the area was settled approximately 172 years earlier and inhabited by settlers during that period preceding the township's establishment.

In 1668, Capt. William Sanford and Maj. Nathaniel Kingsland purchased land from Chief Tantaqua, a Mighecticck Indian. Sanford and Kingsland, retired British colonial officers from the island of Barbados in the West Indies, divided the land that stretched from the Passaic to Hackensack Rivers.

The pair divided the land, with Kingsland taking an area that covered from present-day North Arlington through East Rutherford. Sanford claimed the southern area now known as West Hudson that included Harrison.

Sanford's territory was under the jurisdiction of Newark and Essex County until 1710. The territory then became part of Bergen County. Soon, the farmers and land gentry tired of making the trip from West Hudson to the county seat in Hackensack. The distance was about 15 miles, but it was an arduous journey on dirt roads in that era. The state legislature was petitioned and granted a new boundary. Bergen County's southernmost area stretched to Belleville Turnpike, today at the southernmost end of North Arlington. The area south of Belleville Turnpike became the township of Harrison, part of newly formed Hudson County.

In 1867, the area today forming the towns of Kearny and East Newark petitioned the state legislature to become separate towns. The request was granted, and Harrison's boundaries were revised to the square-mile area it is today. In 1904, the legislature officially gave Harrison, named after our nation's ninth president, a new charter as a town.

In the early part of the 20th century, Harrison was coined the Hive of Industry by Pres. William Howard Taft. Indeed the mile-square town has been home to a number of prestigious and well-known corporations over the years.

Interestingly, this town, small both in size and population, has been the setting for a wealth of interesting stories and events. A number of prestigious corporations, such as RCA, Otis Elevator, and Worthington Pump and Machinery, have made the town their home.

During World War I, residents of Harrison joined together in a concerted effort to make the world safe for democracy. That meant encouraging young men to volunteer and promoting the sale of war bonds. The Harrison auxiliary of the Newark Red Cross pitched in any way they could to strengthen the cause here at home.

At the height of World War II, Harrison made a valiant effort for the cause. Corporations such as Crucible Steel and Driver-Harris, both of which called Harrison home, manufactured supplies used by the military. Residents rallied together and contributed their part to the cause.

No story or mention of Harrison would be complete without a mention of Frank E. Rodgers. With a tenure akin to an Egyptian dynasty, Rodgers gained national notice by serving as the town's mayor for over four decades.

Through the years, Harrison has distinguished itself in the field of athletics. In the early 1900s, a Federal League baseball team called Harrison home. In recent years, Ray Lucas, a product of Harrison High School, has gone on to become a quarterback in the National Football League. On the high school and local levels, the town has seen prominent athletes contribute to successful teams in a number of sports. In recent years, girls basketball and boys soccer have earned plaudits.

Harrison has had its notable personalities and luminaries in other fields as well. Model and television personality Daisy Fuentes grew up here and was the 1984 Harrison High School homecoming queen.

As the years have passed, Harrison has gone through a number of changes. Some of the corporations of past years have relocated, and the population has changed. The western European immigrant population has recently given way to a dominant influx of people from Central and South America.

This publication contains photographs, documents, and memorabilia that attest to the growth and change Harrison has seen through the years. Many of the images in this book refer to the industry that has been synonymous with the town through the years. As important as the industry and commerce has been, it is the people that are the focal point of Harrison and its history. Many of the images throughout these pages show the area residents at work or play.

Chapter 1 deals with the official formation of the township and its pre-20th-century days. Chapter 2 covers the years of growth at the turn of the century and into the early 1900s. Chapter 3 addresses a period that saw Harrison pitch in with its effort during World War II and, three decades later, celebrate our nation's bicentennial. The recent years and a look at Harrison today are provided in chapter 4. Finally, chapter 5 provides a look at the town from a religious perspective, as its various churches have made it a haven of worship.

Harrison is a community that has a special sentiment and significance in the lives of the husband and wife authors Ray and Karen A. Floriani. For Karen, it is a place where most of her family hails from and where she spent her early childhood years. For Ray, it is a place where a good deal of camaraderie and friendships have emerged through his association in athletics.

Researching the history of Harrison and incorporating it with the present has been a true labor of love. Hopefully, the readers will find, as the authors did, that Harrison is a unique place with an abundance of stories.

One
HARRISON'S BIRTH
AND FORMATIVE YEARS

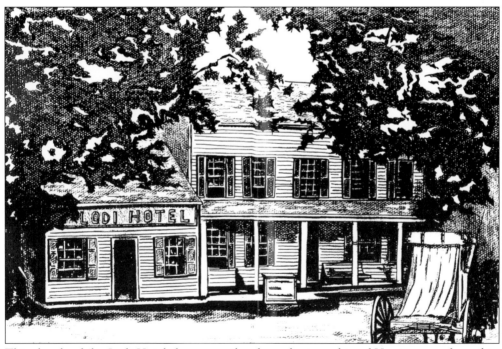

This sketch of the Lodi Hotel shows exactly where the township of Harrison was formed in 1840. In the 1700s, the hotel was a popular place for weary travelers to stop for the night en route to New York. It later became the site of many town meetings. (From the collection of the late Henry Mutz.)

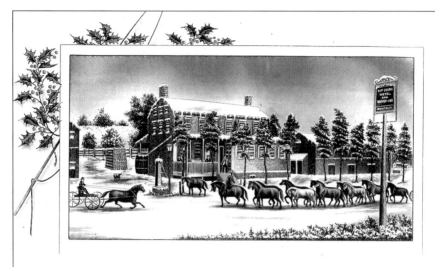

Greetings and Best Wishes for Christmas and the New Year

At this season, when the spirit of the Yuletide invests the earth with good-will and good fellowship, we are prompted to send an expression of regard for the occasions afforded us to be of service.

Our greeting this year depicts an engraving of the old Drover's Inn, one of the earliest landmarks of Harrison, where were held many gatherings and celebrations of importance to this community.

May it bring to you pleasant memories of days gone, together with our sincere wish that your holidays be most happy and the New Year filled with a rich abundance of the good things of life.

West Hudson County Trust Company

William J. David

PRESIDENT

Harrison, New Jersey

On the top of this Christmas card is a lithograph of Drover's Inn. Built in 1818, Drover's Inn was a popular hostelry for much of the century. Travelers making the journey to New York would often stop for the night. Famous guests included Frank Forester, a noted sportswriter who covered outdoor and hunting activities in the 1840s and 1850s. Gen. Philip Kearny also utilized the inn as headquarters while preparing troops for the Civil War. The famous landmark, located on the turnpike (now Harrison Avenue), burned down during the early 1870s. A poem about the inn follows.

> At morn or noon, by night or day,
> As time conducts him on his way,
> How oft doth man, by fate opress'd,
> Find an inn a place of rest!

The operator of Drover's Inn, Hiram Davis (1829–1876), was a distinguished landowner in Harrison. He sold all but three of his 79 acres of prime land and built a mansion on Harrison Avenue in 1873. He was married to Emma Sanford and had eight children. He was an alderman in 1859 and a Harrison township freeholder from 1858 to 1863 and from 1867 to 1869.

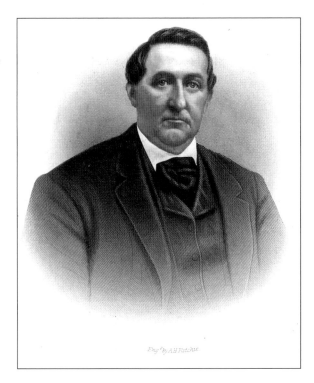

Eng'd by A H Ritchie

Irene Davis (1827–1908) was a sister of the noted and prominent Harrison landowner Hiram Davis.

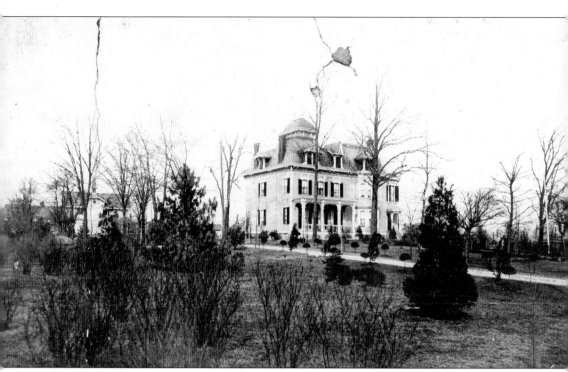

The Davis mansion stands in splendor in this 1890 photograph. Owned by Hiram Davis, the mansion was located at 700 Harrison Avenue. Today, a Little League baseball field is located on Harrison Avenue, taking up part of the land where this mansion was formerly located.

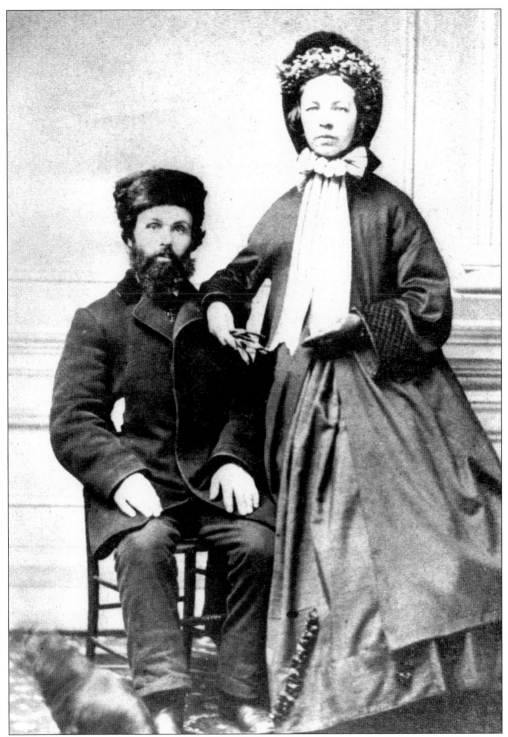

Thomas and Ann James pose for a picture in March 1863. Ann came to Harrison in 1844 and established the first millinery shop, located at 133 Harrison Avenue. Her husband was a saddle maker by trade.

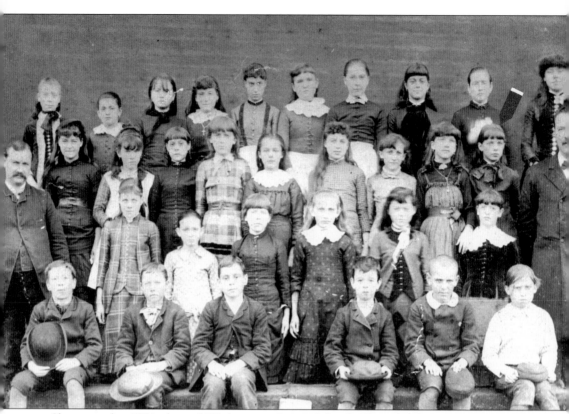

Shown is the 1884 class of Washington Street School. The school was a two-story brick building with seats for 450 students. The first school in Harrison proper, Washington opened its doors in September 1873. John Dwyer (second row, far left) was the first principal.

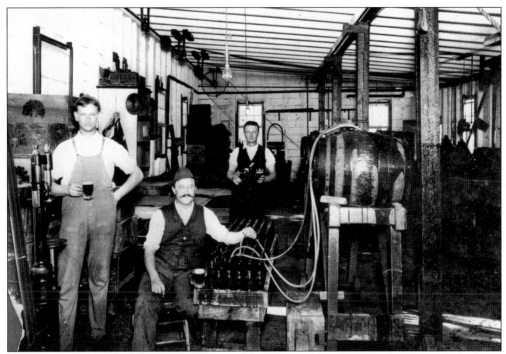

This 1890s photograph was taken at the bottling department of the Peter Hauck Brewery. The brewery was located at Harrison Avenue at the present site of Harrison High School. In the center of the photograph is William Harter, the foreman.

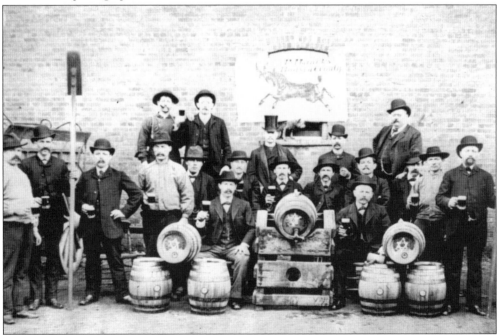

In this 1890 scene, the beer at the Peter Hauck Brewery is blessed. In the middle of the back row is a rabbi (in a top hat), who performed the blessing in accordance with Yom Kippur. On the extreme right in the back row is brewmaster William Englehard.

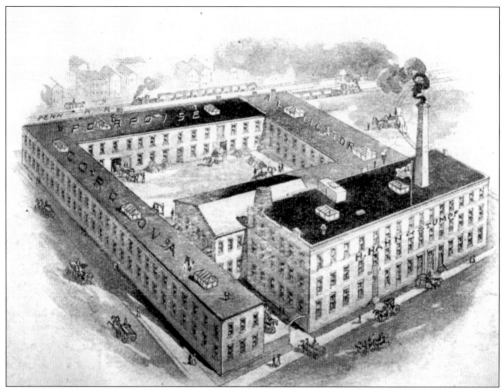

Industry had found a home in Harrison as early as the 19th century. This late-1890s lithograph shows the Stumpf's Tanning Company, at the corner of Dey and Jersey Streets. The tannery was destroyed by fire in 1898.

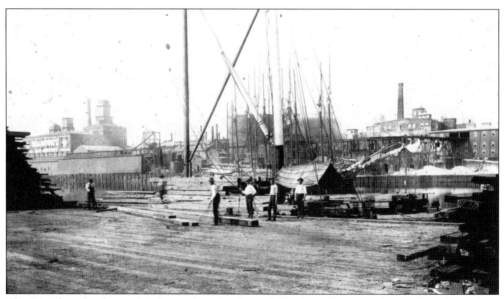

The McGlaus lumberyard is located at the foot of Harrison Avenue. A noted business from Harrison's early days to the present, McGlaus is a large enterprise that includes lumberyards in several other states.

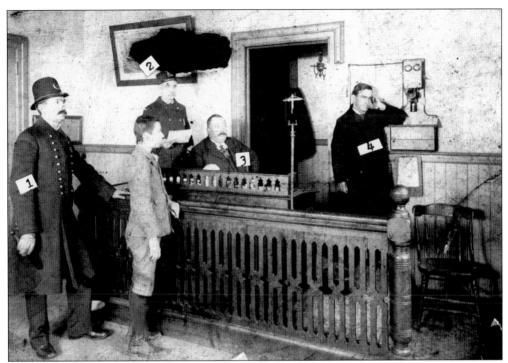

This photograph was taken inside the police station just prior to 1900.

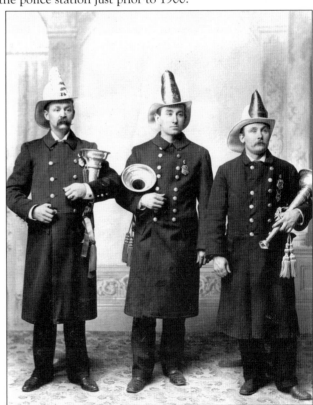

The top brass of the town's fire department poses in 1894. From left to right are Thomas V. Callahan, first assistant; Peter Goodman, chief; and John J. Coburn, second assistant.

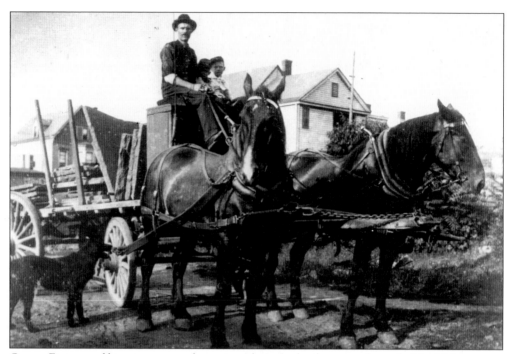

George Fixture and his two sons are shown in a photograph taken near the end of the 19th century. Fixture lived at 301 North Third Street and was engaged in the trucking and excavating industries.

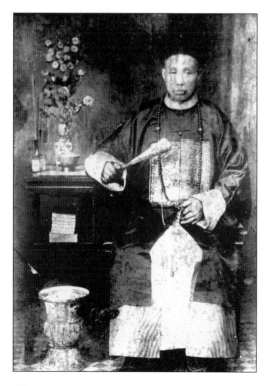

Chin Jim established the Chin Jim Tea Store, the first Chinese store in Harrison, in 1893. The store was located at 312 Harrison Avenue. Jim and his family were also noteworthy for the birth of their son, Willie, the first Chinese child to be born in Harrison. In addition, Jim's daughter was the first Chinese person to wed in Harrison.

Two
THE BEEHIVE EMERGES

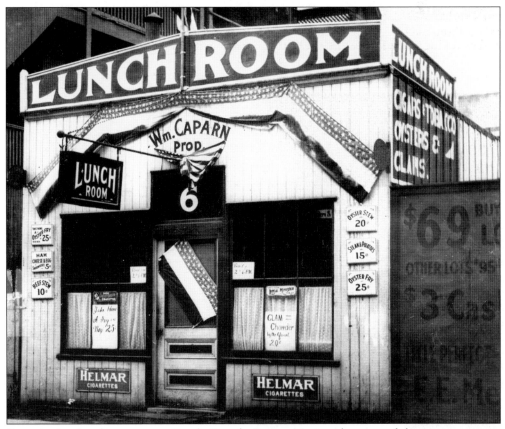

Seen is the luncheonette on South Fourth Street. Notice the turn-of-the-century prices, including a quart of clam chowder for 20¢, listed on the outside of the buildings.

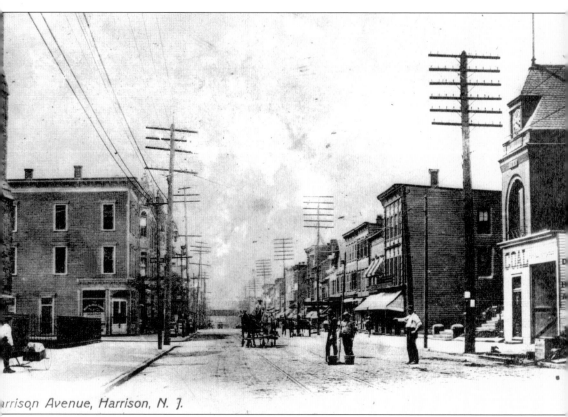

arrison Avenue, Harrison, N. J.

Public service trolley track maintenance workers are busy on the job in 1902. They are dutifully tending to a stretch of track on Harrison Avenue. Shortly after this photograph was taken, West Hudson Bank was organized and located at the first building on the left.

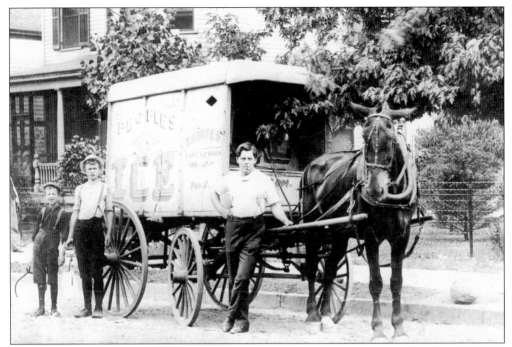

Thomas Yates (in the front) delivers ice on Hamilton Street. Yates was a Spanish-American War veteran.

Joseph E. Brannegan was a noted figure in community service in the early years of the 20th century. Brannegan served as police judge in 1905 and assemblyman from 1912 through 1914.

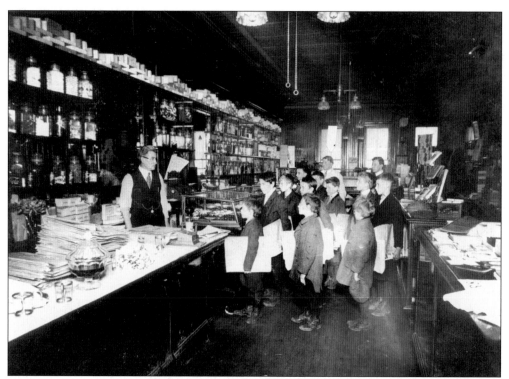

Peter Goodman's newspaper delivery boys meet at the store. Goodman is seen in the rear of the store. Behind the counter is Peter B. Just. The store was located at 311 Harrison Avenue.

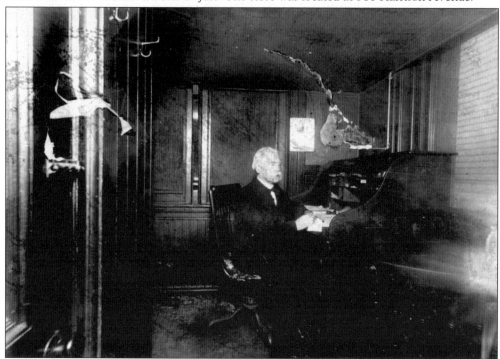

John McKeon is seated in his real estate office at 307 Harrison Avenue.

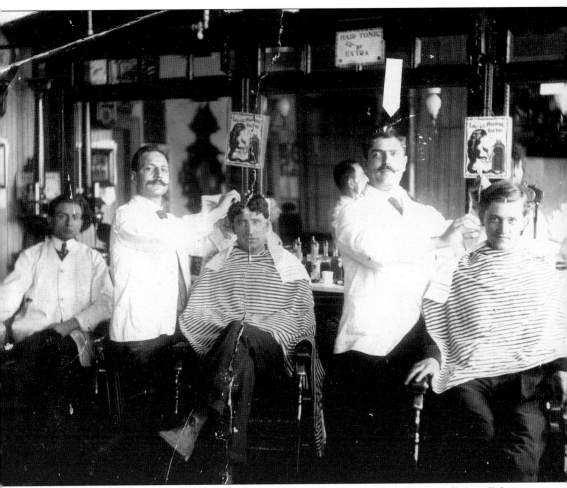

George Alla's barbershop was located on Harrison Avenue. Note the stylish handlebar mustaches on the gentleman in this 1907 view.

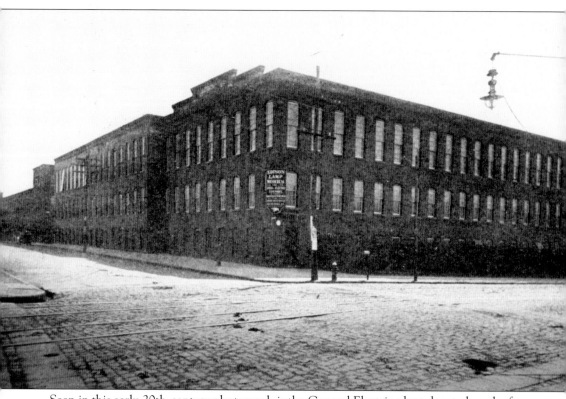

Seen in this early-20th-century photograph is the General Electric plant, located on the former site of RCA. A mini-mall and new homes are now situated on this property.

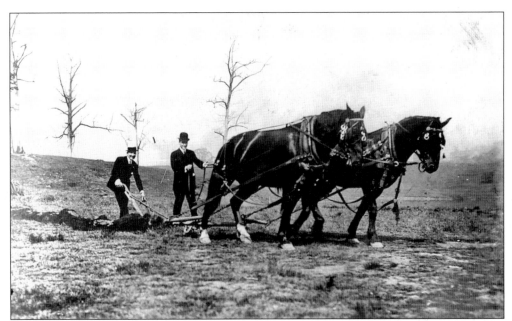

Ground was broken for West Hudson Park on June 15, 1910. Mayor Joseph Riordan is at the plow as Mayor Cornelius A. McGlennon of East Newark pitches in by driving the horses.

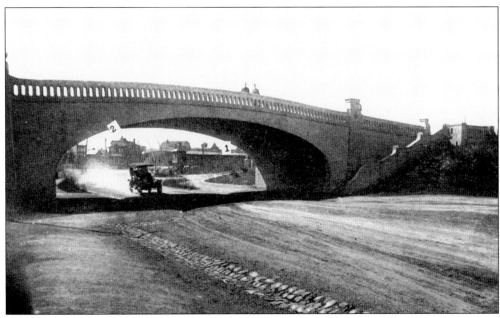

Seen is the bridge over Davis Avenue in West Hudson Park. The bridge stands today and continues to be a popular landmark in the park.

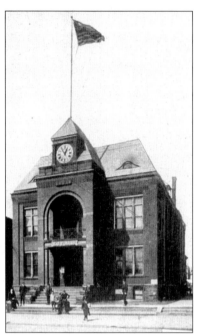

The former city hall, seen here, gave way to the current one in 1936. This photograph dates from 1910.

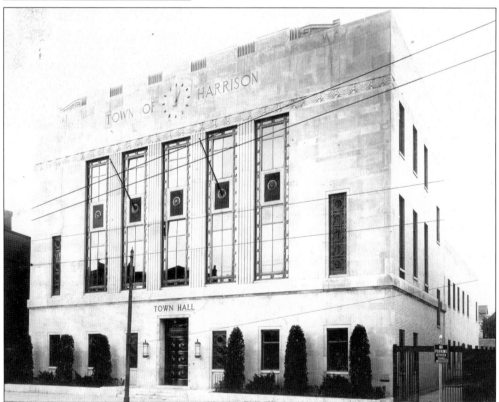

In the late 1930s, this building was billed as "the new town hall." Today, the same edifice still stands and is in use on Harrison Avenue. Just a few cosmetic modifications have been made through the years.

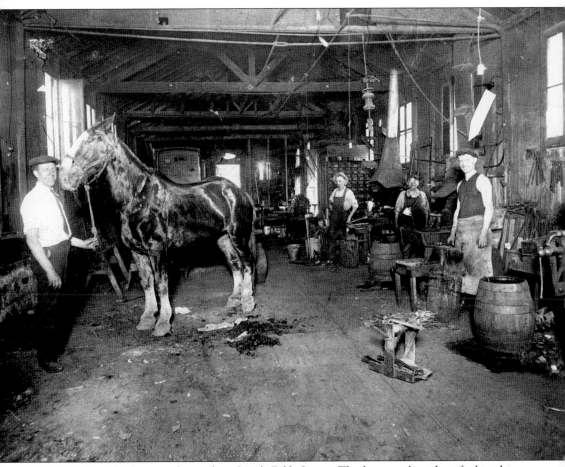

Reilly's Blacksmith Shop was located on South Fifth Street. The lone worker identified in this group is Frank Foster, who is standing on the far right.

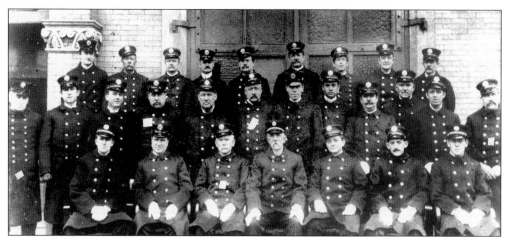

The 1911 Harrison Fire Department poses outside the firehouse. From left to right are the following: (front row) Joe Garrity, Charlie Stell, John Anton, Charlie Shanley, Jim Walker, John Brandt, and Arthur Coakley; (middle row) Peter Goodman, Frank Colburn, John Ryan, Jack Lawless, Tom Duffy, William Crawley, Peter McClure, George Riordan, Ed Garrigan, Charles Biegner, George Young, and Ben McWatters; (back row) ? McDonald, unidentified, Tom Manning, Patrick Carey, unidentified, E. Biegner, Henry Trapper, George Brant, Jon Donnelly, and two unidentified men.

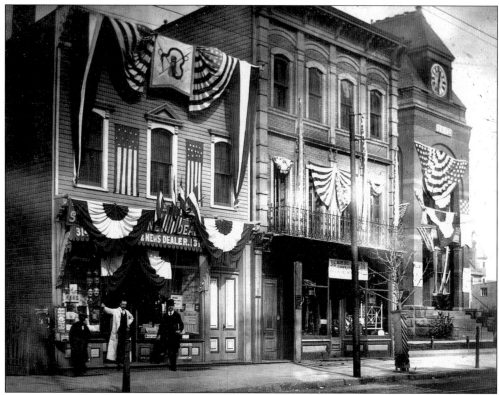

John J. Daly (wearing a white coat) was the second mayor of Harrison. He served from 1915 to 1920. In 1911, the Harrison Fire Department celebrated its 25th anniversary. Daly is seen in front of a store on Harrison Avenue.

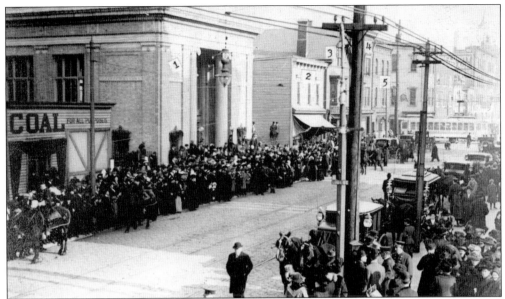

The funeral procession for Fr. Maurice O'Connor left Holy Cross Church and moved down Harrison Avenue on December 13, 1912. O'Connor was a revered figure who labored tirelessly to better the community of Harrison. He was not for prohibition per se, but he worked to ensure the bars would be closed in town on Sundays. On the day of his funeral, Harrison literally shut down and came out to pay its respects. Above, Mulligan Coal is on the left and West Hudson Bank is second from the left. O'Connor is pictured to the right.

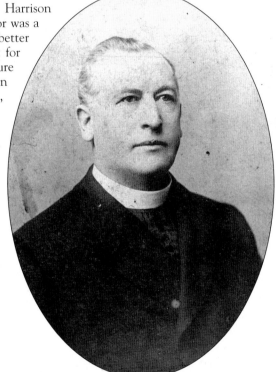

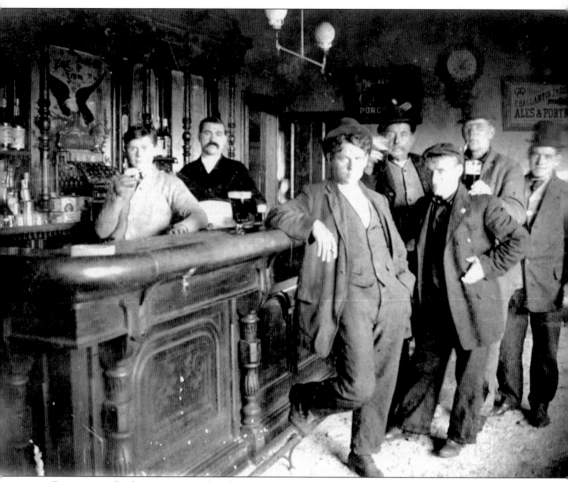

From its early days, Harrison has been a place to find a friendly "watering hole." In the late 1970s, Harrison had 60 bars for a population of 12,242—a bar for every 204 residents. Seen is Dwyer's Tavern, at 214 South Third Street. Behind the bar are Jim (left) and John Dwyer. An apartment building occupies this site today.

Frances (left), Larry (center), and John Fagan find convenient and comfortable transportation in their 1914 trek through Harrison. Although vehicular means were present, it was not at all uncommon to use animals as a way to transport goods or just get around town.

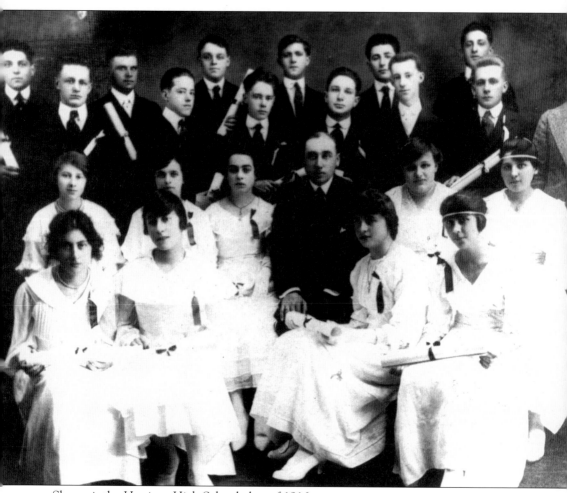

Shown is the Harrison High School class of 1916.

The holidays are celebrated in this message. To the right is a lithograph of Davis Pond. The pond was a popular highlight, as seen in this winter view, with skaters active and trees in the background, and is a scene similar to something out of Currier and Ives. Below is a map of Davis Pond. The pond was a famous meeting place for skating parties for Harrison locals and residents of nearby towns. (From the collection of the late Henry Mutz.)

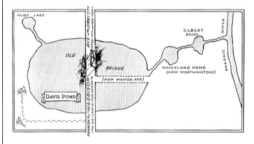

CHRISTMAS DAY OVER 60 YEARS AGO AT DAVIS POND

The festival of Christmas is enshrined for all of us in the scenes associated with our youth.

Over sixty years ago the Davis Pond was a favorite skating place for the youth of the entire countryside and each year resounded to the merriment of old-time Yuletide parties. It was located just below the present car sheds, where the Turnpike Road, now Harrison Avenue, and Manor Avenue are situated.

What can better symbolize the spirit of the Happy Holidays we all are wishing one another?

May much of this old-time spirit of peace and good will come to you and yours, filling your minds, not for one day only, but throughout the years to come.

West Hudson County Trust Co.

William Davis
PRESIDENT

Harrison, New Jersey

"AT CHRISTMAS PLAY AND MAKE GOOD CHEER
FOR CHRISTMAS COMES BUT ONCE A YEAR."
(THOMAS TUSSER—1515-1580)

DAVIS POND, as shown on this Greeting, was situated just below the Harrison car barns on Harrison Avenue. This was a large pond, connected by brooks and little lakes, all fed by the Passaic River, and flowing back to Fairy Lake, which is now in West Hudson City.

The history of transportation in this section began, of course, with the stage coach. The first bridge was built over the Hackensack River, and another over the Passaic River, which is now Bridge Street. These bridges were opened in 1794 and became free bridges in 1873.

The Turnpike Road was known as the Newark and Jersey City Turnpike, and was a toll road. This Turnpike was laid out right through the Pond, dividing it in half, half being on the Davis property and the remaining half on the South Side of the Turnpike, where Manor Avenue is now located. A little bridge connected the two ponds across the Turnpike, which allowed the water to flow from the brooks and small ponds, fed from the Passaic River, back to Fairy Lake in what is now West Hudson Park.

This bridge remained until the Turnpike Road, running through Harrison, became known as Harrison Avenue, and was laid out on August 31st, 1871, when the Pond on the South side of Harrison Avenue, where Manor Avenue is now situated, was filled up in 1873.

The Davis Pond, with its connecting streams and adjoining little lakes, was a favorite meeting place for skating parties from Newark and the entire countryside East of the Passaic River, which was then known as Harrison but is now divided into Harrison, Kearny and East Newark.

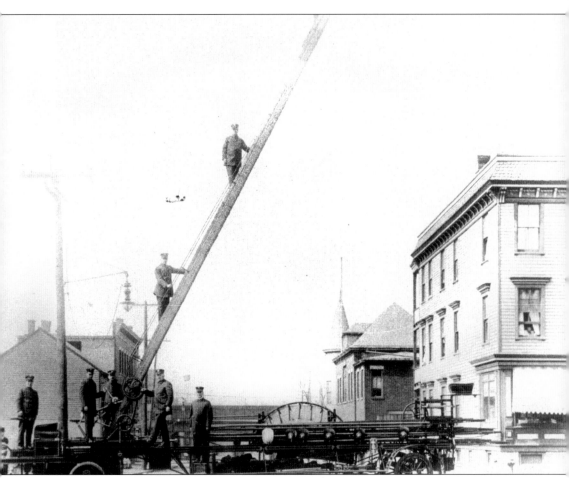

This photograph shows the first paid firemen on a Seagraves engine with a Christie front-drive tractor and a 75-foot telescoping hook and ladder. On the truck are, from left to right, John J. Baker, Bernard Gibson, Charles Johnson, Charles Biegner, and James Langan. Prior to 1917, the town relied on a volunteer firefighting corps.

Minnie Rachow Daubenberger stands behind the counter of her store on South Fourth Street. A Wendy's is currently at this site.

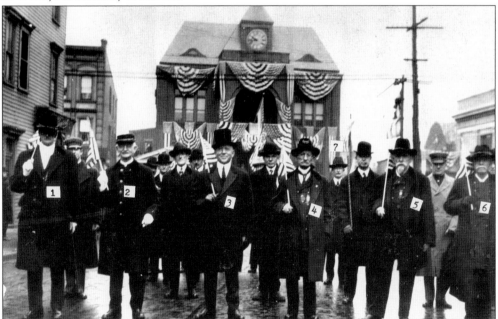

Harrison's contributions to the war efforts of the 20th century are well documented. The town, however, was prominent in these ventures as far back as the Civil War. Here, a group of Civil War veterans poses in 1919. They are Lawrence Fagan (1); Charles C. Dally (2); Mayor Joseph Riordan (3); unidentified (4); Capt. John McAfee (5), the first fire chief (1879); Charles Smith (6); and alderman Frederick Clinton (7), a Republican from the Third Ward from 1909 to 1925.

The dedication of the World War I honor roll took place in the late 1920s.

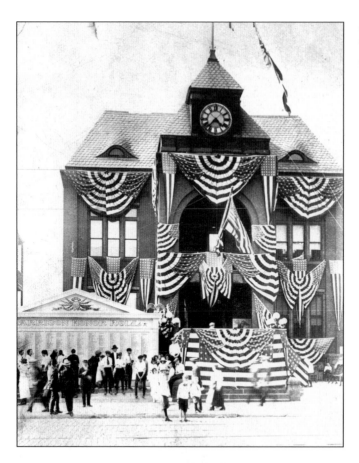

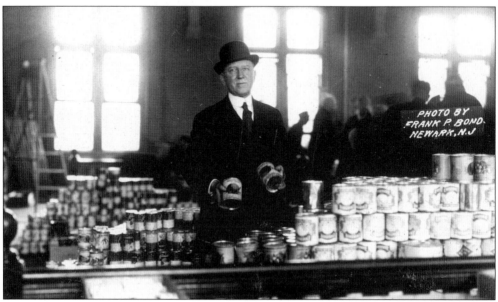

Seen here is the World War I government food surplus sale at the town hall. Mayor Joseph Riordan presides over the sale—another behind-the-scenes war effort in Harrison.

The mom-and-pop store, a staple of the Roaring Twenties, was alive and well in West Hudson. This one was located at 301 William Street.

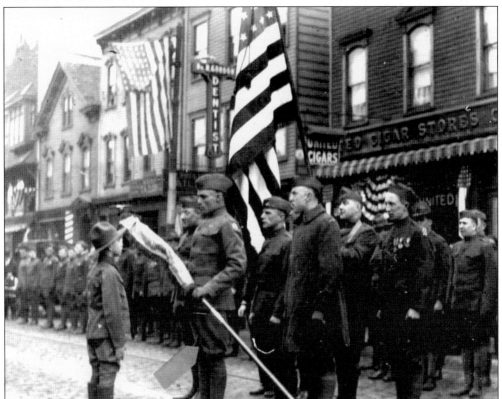

Boy Scout Abraham Strum presents a color standard to the Sgt. William Sawelson Post Veterans of Foreign Wars. The presentation was made in front of town hall on November 24, 1920.

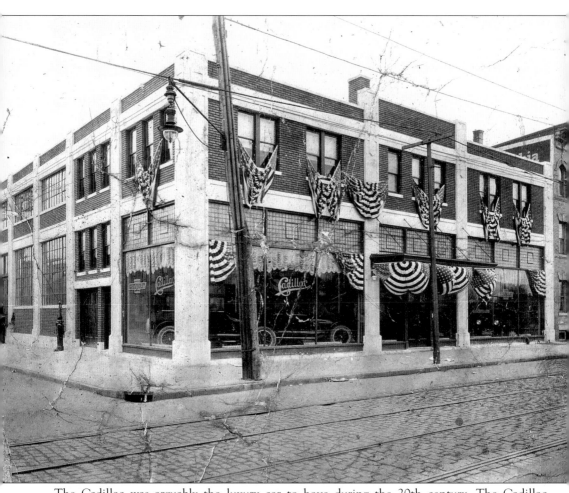

The Cadillac was arguably the luxury car to have during the 20th century. The Cadillac showroom of Larry Fagan was located at 115–117 South Fourth Street.

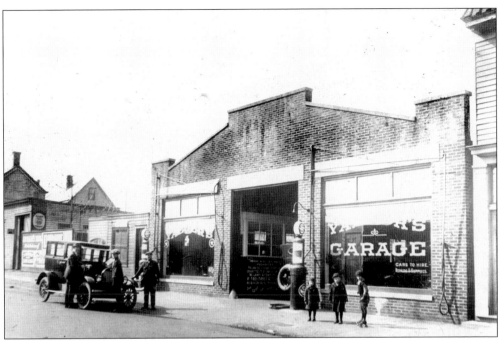

Seen is Yeager's Garage, at 520 Hamilton Street. On the far left are, from left to right, Fidel Yeager Sr., Dick Desmond, and Alex Muslvski. The boys on the right are, from left to right, John Yeager, Fidel "Mickey" Yeager, and Milton Kosdun.

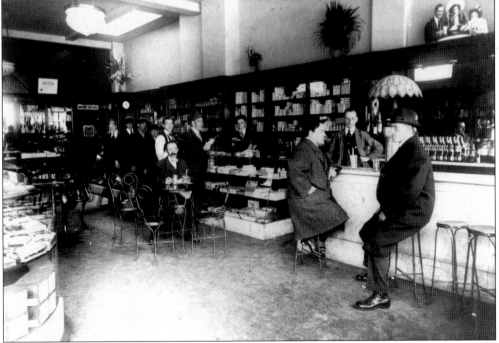

Standing behind the counter in this view of Mulligan's Drugstore, at 335 Harrison Avenue, are Dr. William McGlennon (left) and Dr. A.A. Mulligan. Notice how most of the store was strictly engaged in the sale of medicines and pharmaceuticals, a contrast to today's pharmacies.

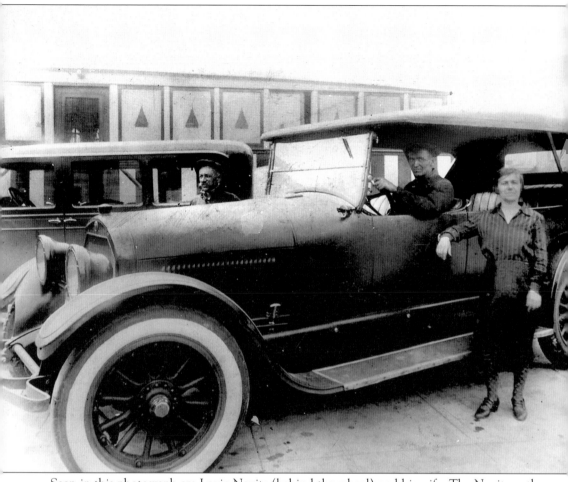

Seen in this photograph are Louie Nevitz (behind the wheel) and his wife. The Nevitzes, the owners of a gas station at 15 Passaic Avenue, also owned the Puritan Diner (in the background) on that same property.

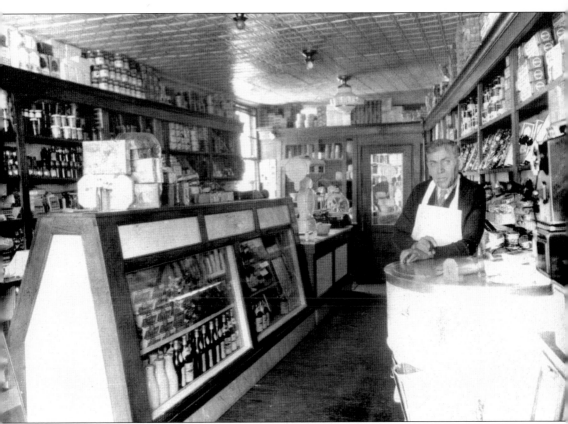

Sam Katz is pictured in his delicatessen on South Fourth Street in 1930.

The 1931 graduating class of Harrison High School poses for a photograph. From left to right are the following: (first row) Helen Noniewicz, Helen Gallahger, Regina Jacobs, Nettie Kasparavek, Lucille Farese, Eva DiSabato, Theresa Falivene, and Mary Roman; (second row) Genevieve Comes, Cecelia Pawlowicz, Walter Gibbs, John Palmer, Leo Conches, Ted Czaya, Mary Nuzer, and Sara Davis (teacher); (third row) ? O'Neill, ? Healy, ? McGuire, Frank Tavernese, Frank Cicone, Edward Polding, unidentified, ? Colley (teacher), and ? Honan (teacher); (fourth row) Anthony Calbro, Anthony Tortoriello, Erwin Wackenhuth, ? Manning, ? Grant (vice principal), Fred Shields, George Grochowski, Joseph Ferrerro, ? Fixter, Michael Ariana, John Durkin, and Sal Viscuso.

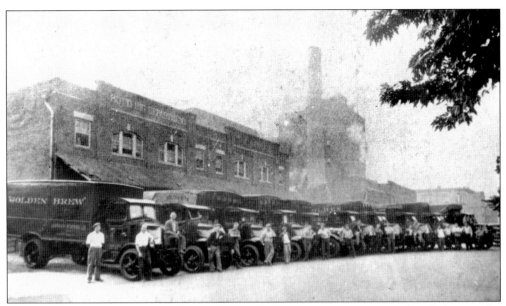

This early-1930s photograph shows the Peter Hauck Brewery, which produced the popular Golden Brew.

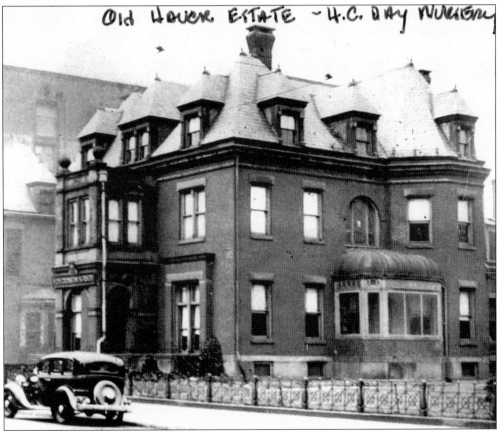

The old Hauck estate later became the Hudson County Day Nursery.

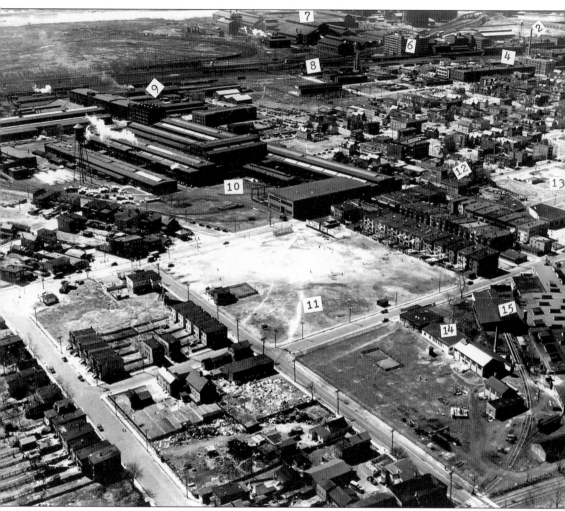

This is a 1939 aerial view of Harrison. The companies and lots are labeled as follows: Otis Elevator (1); Driver-Harris (2); Heinz's warehouse (3); RCA (4); public service gas (5); Hyatt Bearings (6); Crucible Steel (7); Reuther Foundry (8); Campbell Foundry (9); Worthington Pump and Machinery (10); recreation fields (11); Newark Barrell Company (12); former site of carbarns, now the Little League field (13); Schrivers' Foundry (14); Allcraft Corrugated Company (15); and Kullman Dining Car Company (16). Today, Harrison Gardens is situated on the area where the recreational fields were located.

This 1910 view shows the post office on Harrison Avenue.

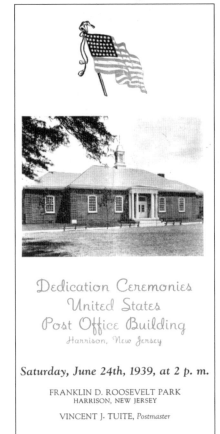

Dedication Ceremonies
United States
Post Office Building
Harrison, New Jersey

Saturday, June 24th, 1939, at 2 p. m.

FRANKLIN D. ROOSEVELT PARK
HARRISON, NEW JERSEY

VINCENT J. TUITE, *Postmaster*

By the time this 1939 photograph was taken, the post office had its own building, just off the main thoroughfare, on Harrison Avenue.

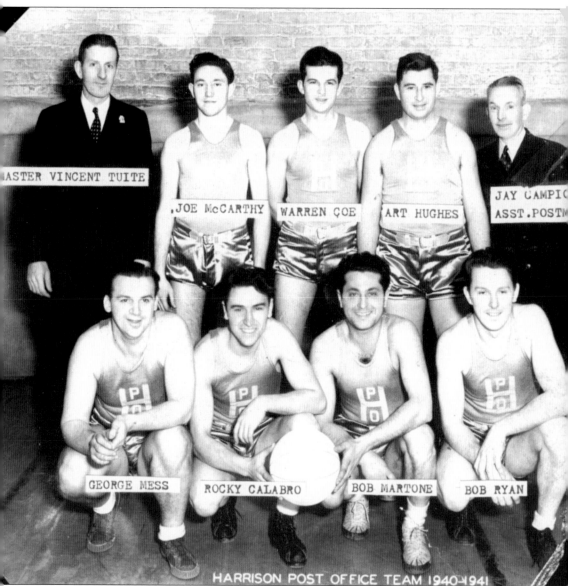

The Harrison post office had a basketball team, shown in this team photograph for the 1940–1941 season. From left to right are the following: (front row) George Mess, Rocky Calabro, Bob Martone, and Bob Ryan; (back row) Vincent Tuite (the postmaster), Joe McCarthy, Warren Coe, Art Hughes, and Jay Campion (the assistant postmaster).

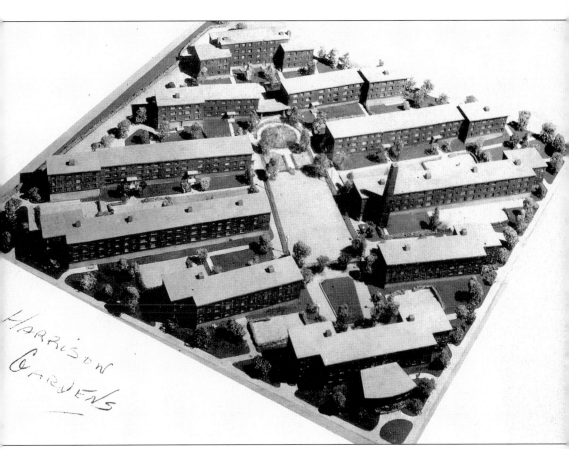

Seen here is an aerial view of Harrison Gardens. The units were subsidized housing that many postwar veterans found a convenient place to settle.

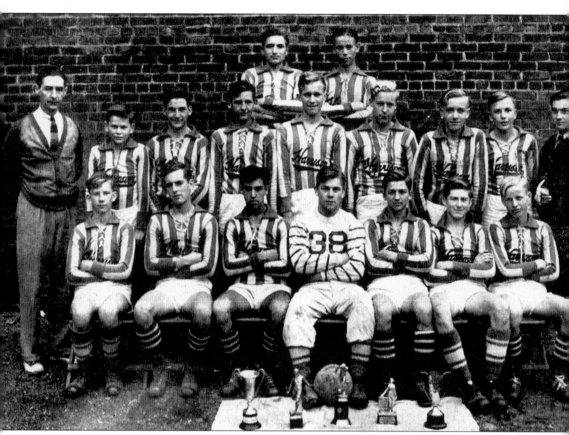

Soccer was a popular sport and one that was played extremely well in Harrison even as far back as 60 years ago. This photograph appeared in a program for a testimonial dinner that honored the 1940 New Jersey high school state champions.

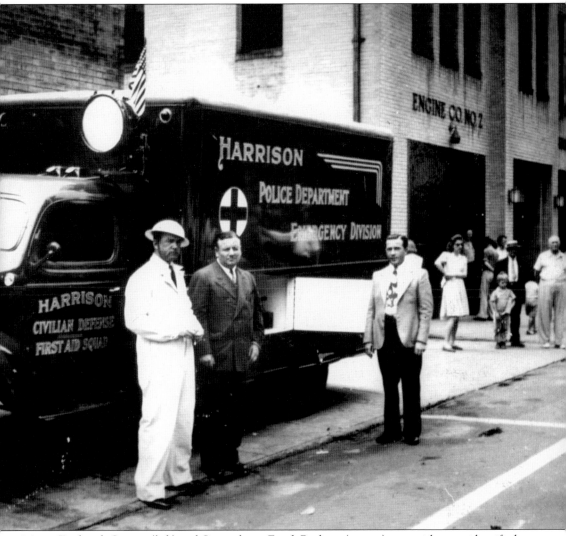

Mayor Frederick Gassert (left) and Councilman Frank Rodgers (center) pose with an unidentified man in 1941. Rodgers would later become mayor and remain in office until the 1990s.

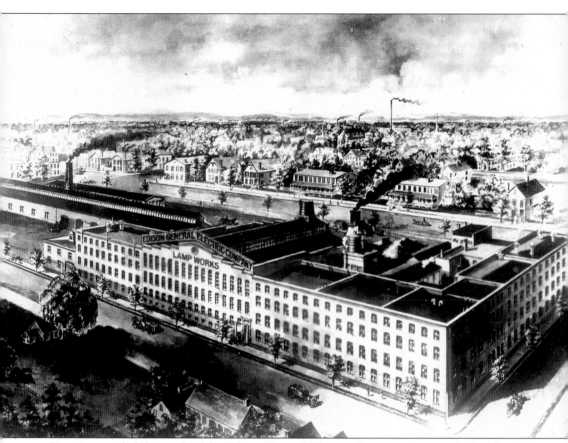

Seen is an early lithograph of the Edison General Electric Company lamp works building. The plant relocated from Menlo Park due to the greater availability for industrial space that was present in Harrison.

Three
WORLD WAR II THROUGH
THE BICENTENNIAL

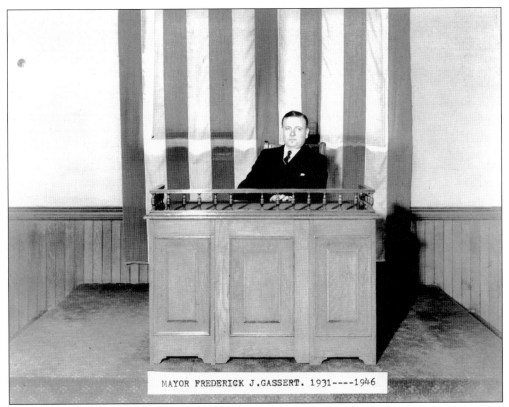

MAYOR FREDERICK J.GASSERT. 1931----1946

Mayor Frederick Gassert, who presided over the town from 1931 through 1946, was succeeded by Frank Rodgers, who also had quite a lengthy stay in office.

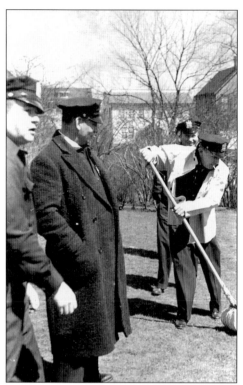

Here, auxiliary police train in West Hudson Park. The park, a popular recreational site today, was often used for training and drilling purposes. Seen below, the emergency police vehicle is in the background.

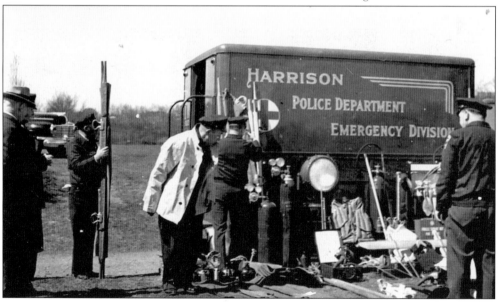

This program was used for a testimonial dinner honoring James Goodman, who published the *Scratch Sheet*.

REUNION DINNER

Goodman's
Scratch Sheet

MARCH 30, 1946

Tendered in Honor of

JAMES J. GOODMAN
Publisher
WILLIAM H. HILDINGER
Editor

**

Invited Guests

Peter B. Goodman....Art Director
Edward Ryan.......Fashion Editor
Thomas Congalton....Navel Expert

**

The Committee

Edwin Tanski, Chairman
Edwin Borkowski
Stephen Dobosh

**

BEN & BUCKY'S TAVERN----313 CROSS STRE

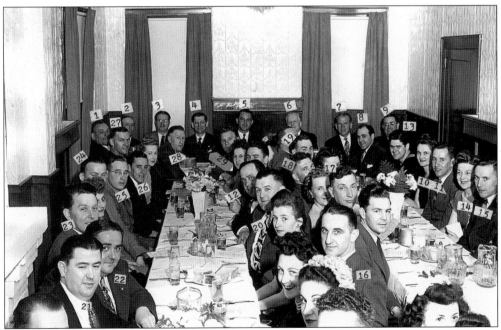

This view shows some of the guests who were in attendance at the dinner. The *Scratch Sheet* was a local mimeographed paper that kept Harrison residents informed during World War II. The party was thrown by a number of veterans who frequented Goodman's store, on Harrison Avenue.

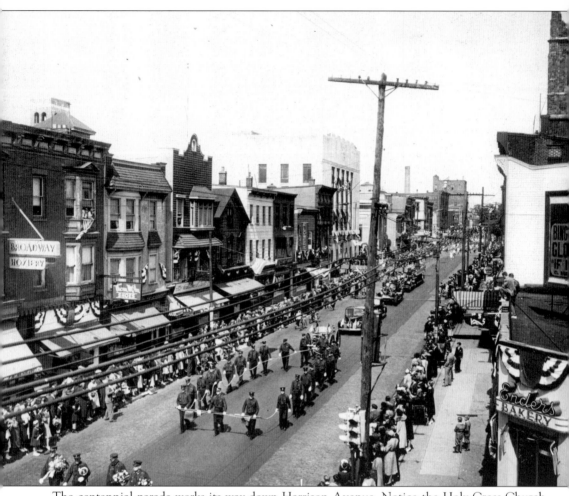

The centennial parade works its way down Harrison Avenue. Notice the Holy Cross Church steeple in the upper right-hand corner. In the window on the far right is a sign advertising a Bing Crosby production.

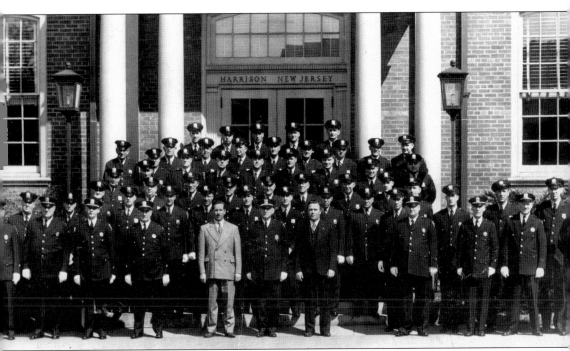

The Harrison Police Department poses in front of the town post office in this 1947 photograph. In the first row, sixth and seventh from the left, are Police Chief Mike Bergen and Mayor Frank Rodgers, respectively.

Ceremonies Mark Opening Of 26 Apartments In Cleveland Avenue

Veterans' Court, a 26-unit veterans' housing project at Cleveland avenue and Hiram street, Harrison, was formerly opened yesterday afternoon following ceremonies which featured addresses by Mayor Rodgers, Charles Erdmann, head of the State Department of Economic Welfare; William T. Vanderlipp and Davis S. Lawrie of the Division of Public Housing.

Many of the 26 families of veterans, previously selected by the screening committee of the Harrison Emergency Housing Committee, immediately took possession of their new homes. The tenants signed leases for the new units at a meeting of the Emergency Committee Tuesday night in the Town Hall.

The ceremonies attended by several hundred, included selections by the Harrison High School Band.

Opening of the Cleveland avenue apartments completes the major portion of the housing committee's work. Frank McWatters, manager of the project, said he expects the eight additional units allocated by the state, to be completed within three weeks.

Members of the housing committee are Town Attorney Michael Bruder, Police Judge Gallagher, Hhigh School Principal Grant, Alexander Rodgers, Harry Handrack, Al Stoll, Edwin Borkowski, Aloysius Ryan, Henry DiSabato, Ray Sardow, Bernard Marrazzo and McWatters.

This newspaper clipping announces that the veterans are moving into housing on Cleveland Avenue.

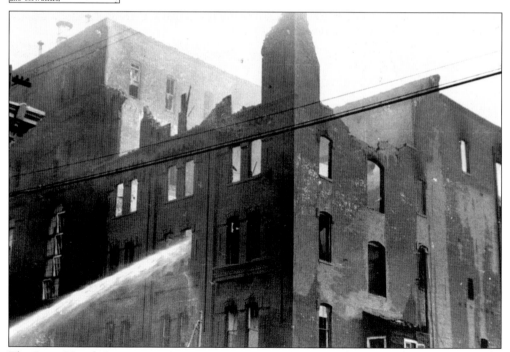

The Peter Hauck Brewery, on Harrison Avenue, suffered through a fire that nearly destroyed the structure. The 1952 blaze saw firefighters summoned from several communities and was visible for nearly 15 miles. The damage to the brewery was estimated at $150,000.

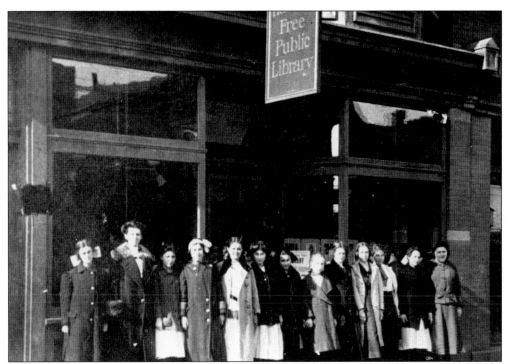

Above is the original library, located at 616 Harrison Avenue. Below is the current library, which was constructed in 1937. The library sits about 50 yards back from Harrison Avenue. It has served the community not only as a cultural center but also as a meeting place for residents rallying to support the country during World War II.

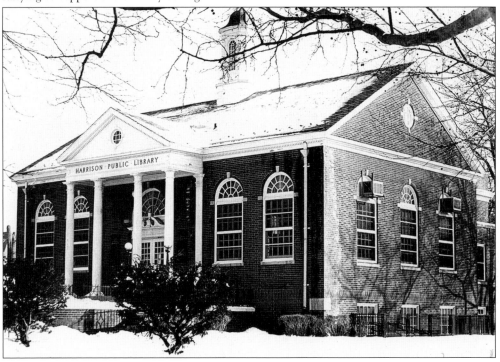

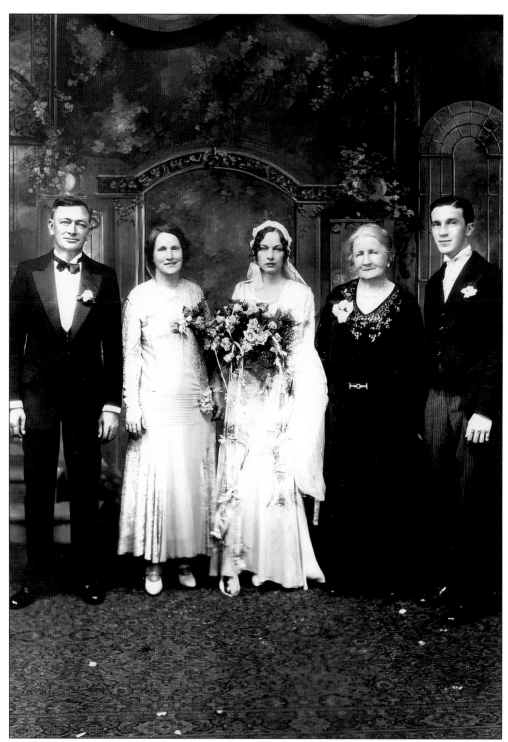

In this photograph of the wedding of Frank Rodgers are, from left to right, the parents of the bride, Eleanor Baker (the bride), Joanna Rodgers (the mother of the groom), and Frank Rodgers (the groom). The wedding took place in the early 1930s and was later bestowed a papal blessing.

The official program commemorating Harrison's 150th anniversary gave a brief rundown of the town's highlights and celebrated Harrison's reputation as the Hive of Industry.

Centennial Celebration

1840

HARRISON

1940

PUBLISHED BY THE MAYOR AND COUNCIL OF THE TOWN OF HARRISON, NEW JERSEY

A Message

It is one of the happiest and most sincerely appreciated events of my life to extend congratulations and greetings to my people of Harrison on the occasion of our town's centennial celebration. I am indeed conscious of the greatness and seriousness of this event in our community life. The 100th anniversary of any progressive community affords occasion for pride in the review of its advancement. I welcome the opportunity to urge my fellow townspeople to share in that pride. At the same time, however, let me suggest that we temper it with thanksgiving, rather than merely exalt it into smug satisfaction.

No community attains a century of progress by virtue of the accomplishments of individuals or single groups to the exclusion of others. More especially is that true in the case of Harrison, to whose beginning and growth so many peoples have contributed.

Let us be proudly thankful for the sturdy settlers who laid so firm a community foundation; for the fine independent spirit of those who followed and who gave such great impetus to Harrison's growth in the middle years; for the national and cultural attributes of our many settlers of more recent years; and for the ideal of Americanism which has welded these various peoples in a common bond of community interest and good citizenship.

Above all else, let us reserve in the midst of our rejoicing a devout gratitude to Almighty God, from Whose providence we have had much and more, perhaps, than we deserved.

The occasion moves me to one more hope: That in this centennial celebration we shall not only glory in Harrison's past, but shall find in it the inspiration, encouragment and firm resolution to dedicate at least part of our daily lives to its greater future.

Mayor

This message, on the inside cover of the 150th celebration program, is from Mayor Frederick Bossert.

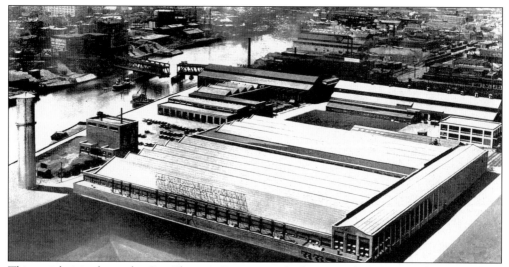

This aerial view shows the Otis Elevator Company, which operated in Harrison for many years. Otis was responsible for manufacturing elevators for two-story buildings to skyscrapers throughout the country. The plant constructed 80 elevators that were used in the World Trade Center.

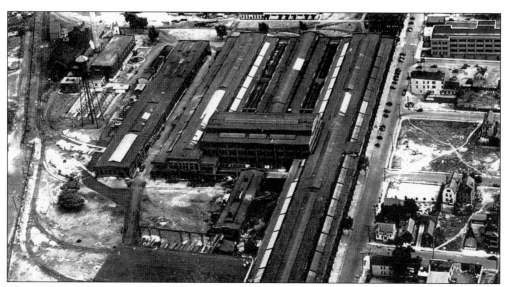

The Worthington Pump and Machinery Corporation was located on Harrison Avenue and encompassed more land than that of a city block. The company manufactured machinery and pumps that were used in many ways, from household use to military use. Worthington had a contract with the U.S. Navy for a number of years. Unfortunately, the plant, which employed numerous Harrison residents through the years, closed down in the latter part of the 20th century.

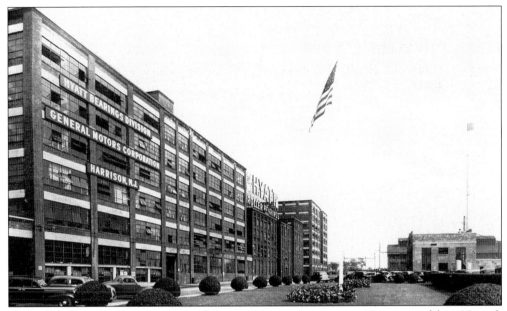

Seen is the Hyatt Bearings Division of General Motors Corporation. Hyatt moved from Newark to Harrison in 1892 and became a part of General Motors in 1915. It was the largest builder of cylindrical roller bearings in the world. During World War II, it was one of the few eastern plants to win the Army-Navy "E" Award five times.

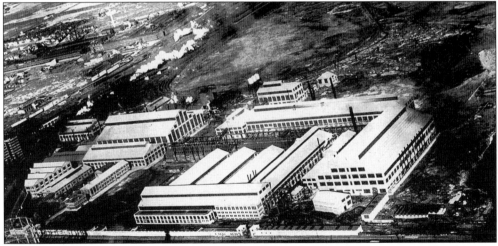

The Crucible Steel Company was located on South Fourth Street for many years. The plant was born out of John Illingsworth's steelworks and Benjamin Atha's Atha Works Enterprise. The plant is not in operation today.

The RCA Corporation took over from General Electric in 1930 and operated in Harrison for many years. By 1968, the company had manufactured its three billionth electron tube. RCA even had an on-site community swimming pool that was open to residents. It was the place for youngsters in town to learn to swim.

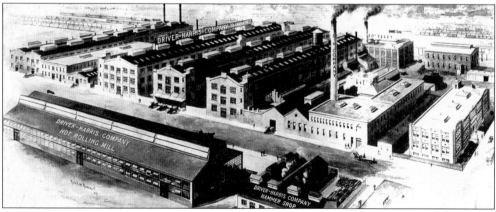

The Driver-Harris Corporation was established in 1902 and is pictured in this drawing from the 1940s. The company also had plants in Ireland, France, and Italy. More than 80 alloys for meeting the needs of the electronics field were manufactured by Driver-Harris. The company was another in Harrison to be cited for its efforts during World War I and World War II.

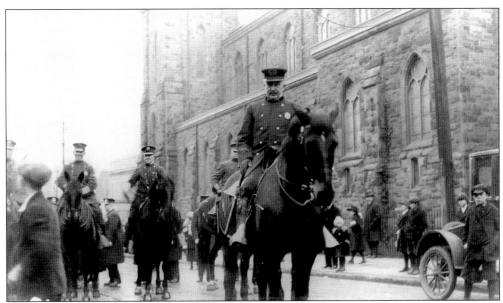

In this Thanksgiving Day 1917 photograph, Michael Rodgers, the longtime police chief, is seated on a horse in the foreground. The setting is Church Square, by Holy Cross Church, where the World War I veterans memorial was dedicated.

Resolved by

The New Jersey State Association of Chiefs of Police

Whereas, it has pleased the Great Creator in His infinite wisdom to remove from our midst our fellow member,

Michael Rodgers
Retired

we record our deep sense of loss in his death. We admired and respected him as a public official and cherished those qualities which bound him so closely to us as a friend and associate. He was faithful to the trust reposed in him by the people whom he served and the record of his public career as a citizen of the State, a public official and also his private life may well be emulated by the youth of the community in which he lived and which he served so well.

Resolved, that we tender to the family of the deceased in this the hour of their darkest bereavement, our sincere, heartfelt condolence, trusting that a knowledge of the esteem and respect in which he has always been held, by his numerous friends and intimate associates, for the many estimable and noble qualities which he possessed, may in a measure assuage the grief which is theirs in a loss so irreparable, and commend them to the care and protection of the Great Father of all. Be it further

Resolved, that these resolutions be spread in full on the minutes of this association, and a copy suitably engrossed presented to the family. And be it further

Resolved, that a copy of these resolutions be presented to the Police Department of the

of which for so many years he was the honored head.

President.

Secretary.

Committee.

The New Jersey State Association of Chiefs of Police issued a special proclamation to remember the passing of Michael Rodgers.

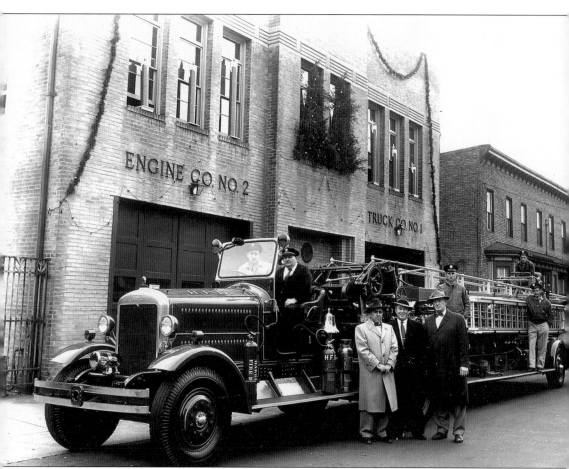

The fire department shows off a truck that was remodeled following the Camden brewery fire. Seated behind the wheel is Capt. Peter Goodman. Standing next to the truck are fire chairman O.J. DeSalvo (left), Mayor Frank Rodgers (center), and Chief Walter P. Tuite.

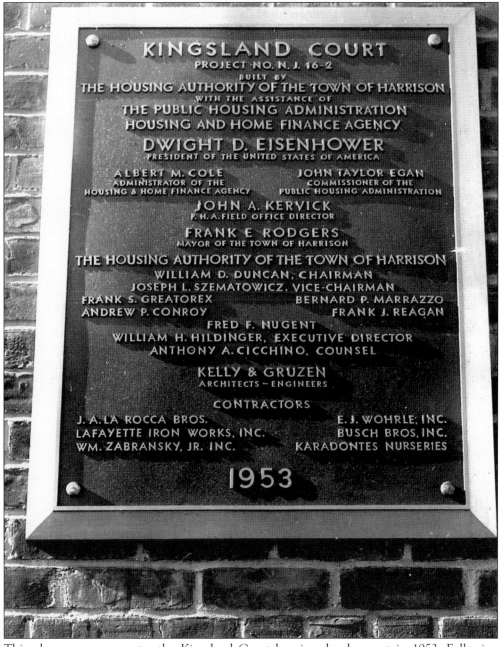

This plaque commemorates the Kingsland Court housing development in 1953. Following World War II, housing developments surfaced in a number of communities.

HARRISON, NEW JERSEY
OFFICE OF THE MAYOR

FRANK E. RODGERS
MAYOR

A PERSONAL MESSAGE

WE WHO ARE INTERESTED IN GOOD GOVERNMENT ARE NATUR-
ALLY DESIROUS OF BEING OF SERVICE TO YOU THROUGH ONE OFFICE OR
ANOTHER AS PUBLIC SERVANTS; BECAUSE OF THIS, WE RESPECTFULLY
SEEK YOUR CONTINUED SUPPORT.

DURING MY TWO TERMS AS MAYOR I HAVE EARNESTLY TRIED
TO MAKE OUR COMMUNITY A BETTER PLACE IN WHICH TO LIVE. I AM
GLAD TO BE ABLE TO HIGH-LIGHT SOME OF OUR ACCOMPLISHMENTS
THROUGH THE MEDIUM OF THIS PAMPHLET. THESE OBJECTIVES HAVE
BEEN BROUGHT ABOUT WITH THE COOPERATION OF THE ENTIRE COUNCIL
IN A MANNER WHICH STILL ALLOWS US TO ENJOY THE LOWEST TAX RATE
IN THE COUNTY OF HUDSON.

OUR ADMINISTRATION HAS PUT AN ACCENT ON THE WELFARE
OF OUR YOUTH, AN INVESTMENT WHICH WILL PAY DIVIDENDS AS OUR
CHILDREN GROW INTO MANHOOD AND WOMANHOOD.

WE IN HARRISON ARE PROUD OF THE RECORD THAT IS BEING
MADE BY CONGRESSMAN PETER W. RODINO, JR. HIS EFFORTS IN BEHALF
OF THE PEOPLE OF THE TENTH CONGRESSIONAL DISTRICT AND THE OTHER
COMMUNITIES THROUGHOUT THE NATION ENTITLE HIM TO YOUR VOTE,
ESPECIALLY IN THE LIGHT OF THE KOREAN SITUATION. PETE RODINO,
AS YOU MAY REMEMBER, WAS COMMISSIONED ON THE BATTLEFIELD IN
WORLD WAR II. HE KNOWS THE PRICE OF FREEDOM AND DEMOCRACY, AND
HE WILL BE ALWAYS ALERT TO PRESERVE THESE IDEALS AS YOUR REPRE-
SENTATIVE IN THE HALLS OF CONGRESS. YOU WILL FIND HIS NAME ON
THE "A"-LINE, ALONG WITH THOSE OF COUNCILMAN DI SALVO, OF THE
FIRST WARD, COUNCILMAN DOYLE OF THE THIRD WARD, AND OUR DEMO-
CRATIC COUNCILMANIC CANDIDATE, JOHN F. DOLAGHAN OF THE FOURTH
WARD.

I RESPECTFULLY ASK YOU TO ELECT US AS YOUR REPRESENTA-
TIVES FOR THE NEXT TWO YEARS.

SINCERELY,

Frank E Rodgers

FER/JMC

VOTE THE STRAIGHT DEMOCRATIC TICKET
(LINE A)
NOVEMBER 7TH, 1950

RE-ELECT FRANK E.
RODGERS
Mayor, Harrison, N. J.

Paid for by Frank E. Rodgers Campaign Committee

This reelection campaign literature included a personal message from Mayor Frank Rodgers. During his long tenure, Rodgers was always known to reach out and personally address the needs of the people of Harrison. One writer once noted that Rodgers never took a vacation; Harrison was his life.

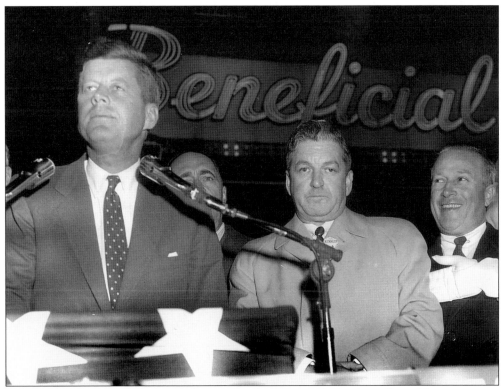

Mayor Rodgers (far right) served the people of Harrison extremely well, and he was a very powerful and influential politician known nationwide. Here, he joins presidential candidate John F. Kennedy (far left) during a 1960 rally in Jersey City.

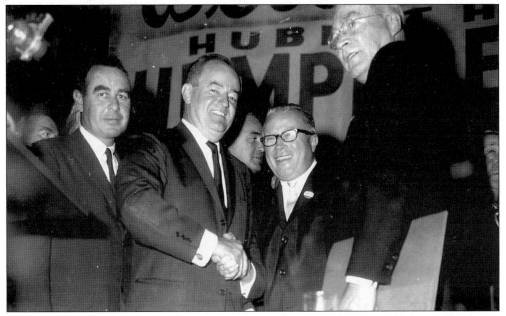

Rodgers shakes hands with presidential candidate Hubert Humphrey in 1968. Ironically, during these campaigns, both Kennedy and Humphrey opposed Richard Nixon for the Oval Office.

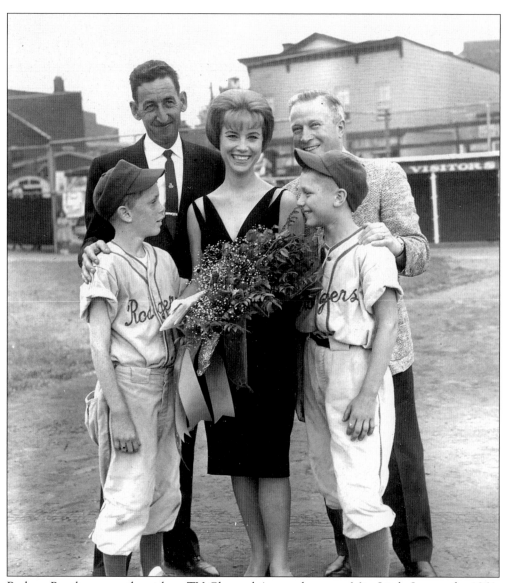

Barbara Bentley, a weathergirl on TV Channel 4, was chosen as Miss Little League for 1961. Here, Bentley receives a bouquet from Don Scott (left) and Tony Rygiel of the Frank E. Rodgers Association at the opening of the National Youth Week observance. It also marked the 10th anniversary of the founding of the town's Little League. Mayor Rodgers (right) looks on with Councilman John H. Flannery, the recreation committee chairman.

Seen is opening day for the Harrison Little League sometime in the 1960s.

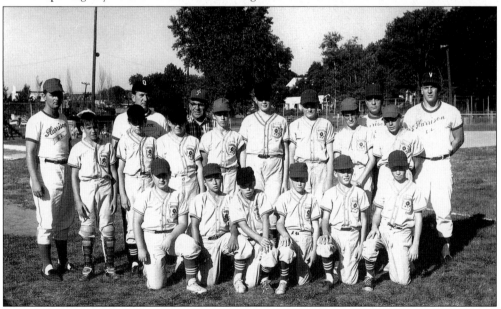

Seen are Harrison Little League all-stars of 1966. In tournament play, this group went the farthest of any Little League all-star team to represent Harrison. They won the districts but were later eliminated by the West New York Americans, who went on to finish as runners-up at Williamsport. Third from left in the front row is Tom Carney, currently a teacher and girls soccer coach at Harrison High School. In the middle of the back row is the team's best player, pitcher, and first baseman, B. Healy.

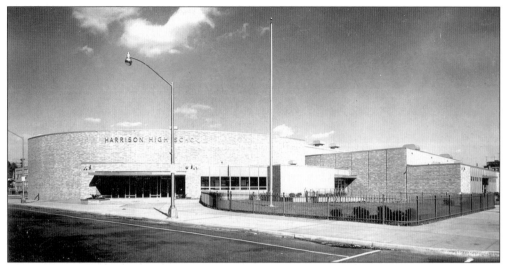

Seen is the new and current Harrison High School. The former school was located on Hamilton Street and moved to Harrison Avenue in 1962 at the location of the old Peter Hauck Brewery. To this day, there are tunnels below the high school that were used by the brewery during its days of operation.

The twist and mashed potato were the craze during the testimonial dinner to honor the first graduating class at the new Harrison High School. The celebration was held in the school gymnasium on June 10, 1963.

Dancing classes were a part of the formal education scene. In this photograph, the instructor leads and students follow during a session at Lincoln School.

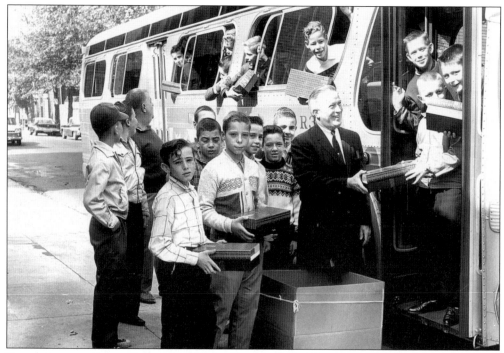

Recreation was always a big part of life for Harrison kids. Here, Mayor Rodgers stops by to see a group of youngsters before they leave for a New York Yankees game in 1962.

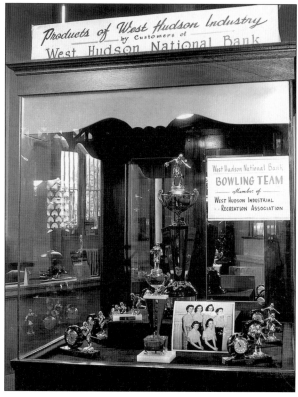

The exploits of the West Hudson National Bank bowling team are honored in a storefront window. This photograph was probably taken in the early 1960s.

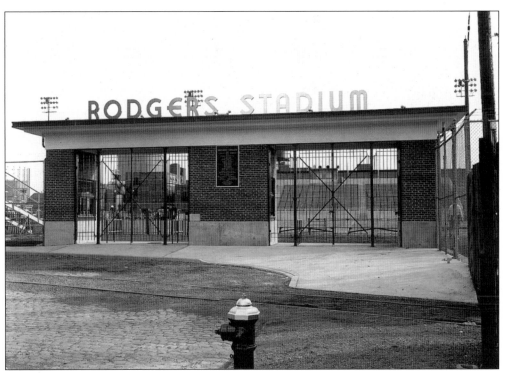

This is an outside view of Rodgers Stadium at the entrance.

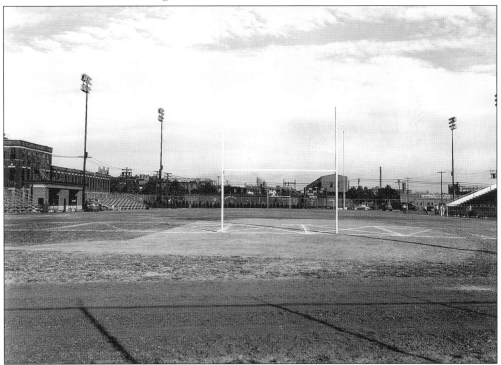

Inside the stadium, football, soccer, and baseball games have been played over the years. Note the old-style, twin-post goalposts that were in vogue during this era.

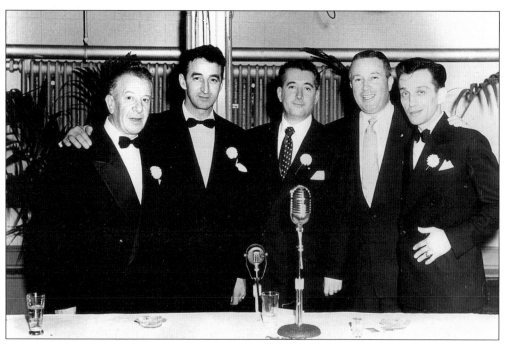

Seen here are, from left to right, an unidentified man, Councilman A. Cifelli, Congressman P. Rodino, Mayor Frank Rodgers, and S. Grabowski. Rodino headed the Watergate Commission in the early 1970s.

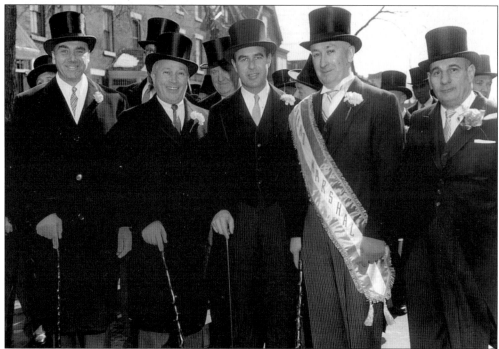

Second from left in this parade picture is Mayor Rodgers. On the extreme right is Mayor Hugh Addouizzio of Newark. Addouizzio's days as Newark's mayor in the late 1960s were well chronicled and controversial to say the least.

BAND

§§§§

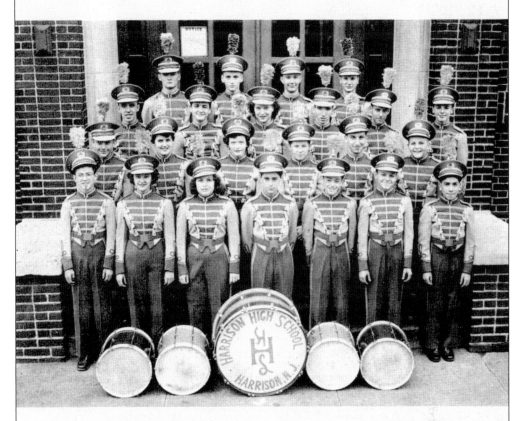

FIRST ROW: JOHN HONAN; DOROTHY COPPOLINO; MARY ANDRONACO; FRED CARUSO; JOHN DeFILLIPPO; EDWARD POZARYCKI; VINCENT FRANCO.

SECOND ROW: CHESTER ROGINSKI; JANE MOORE; KATHERINE MULLEN; RAYMOND HEANEY; ROBERT DAVIS; JOHN HOLEVINSKI.

THIRD ROW: HAROLD ELTING; JOHN SILVERS; ALICE SMITH; TOM RODGERS; JOE McDONOUGH; STANLEY POZARYCKI.

FOURTH ROW: JOHN DAVIS; TOM MUIR; WILLIAM MIKULWICZ; WILLIAM POLLACK.

DIRECTOR
ADRIAN K. BURKE

Through the years, the Harrison High School band has been more than an extracurricular activity; the band has entertained many. Here is a 1950 photograph of the group. The director of the band was Adrian K. Burke (not pictured).

WELCOME TO THE

H. A. R. B. C.

ETHNIC FESTIVAL

MAY 3RD, 1976

This program and announcement celebrated our nation's bicentennial and Harrison's ethnicity, which comprises a true melting pot of different backgrounds and heritages. More than 20 countries were represented in the ethnic celebration.

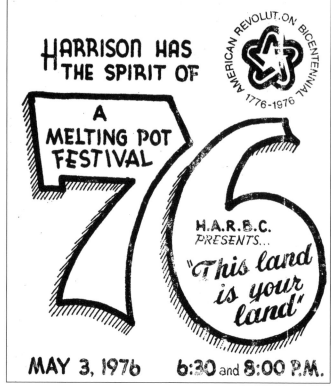

THE TOWN OF HARRISON

American Bicentennial Committee

Cocktail Ball

Saturday Evening, November 20, 1976

6:00 o'clock to 11:00 o'clock

to be held at

Harrison High School Gymnasium

COCKTAILS AND HORS D'OEUVRES

164 Donation $6.00 per person

COCKTAIL

COCKTAIL

Seen is a ticket to the cocktail ball held as part of the bicentennial festivities.

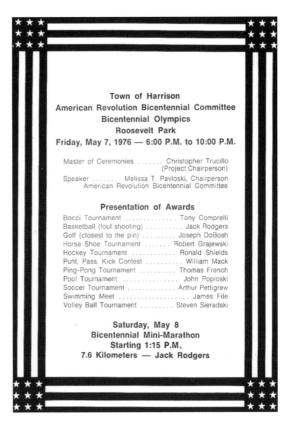

Town of Harrison
American Revolution Bicentennial Committee
Bicentennial Olympics
Roosevelt Park
Friday, May 7, 1976 — 6:00 P.M. to 10:00 P.M.

Master of Ceremonies Christopher Trucillo
(Project Chairperson)
Speaker Melissa T. Pavloski, Chairperson
American Revolution Bicentennial Committee

Presentation of Awards

Bocci Tournament Tony Comprelli
Basketball (foul shooting) Jack Rodgers
Golf (closest to the pin) Joseph DoBosh
Horse Shoe Tournament Robert Grajewski
Hockey Tournament Ronald Shields
Punt, Pass, Kick Contest William Mack
Ping-Pong Tournament Thomas French
Pool Tournament John Poploski
Soccer Tournament Arthur Pettigrew
Swimming Meet James File
Volley Ball Tournament Steven Sieradski

Saturday, May 8
Bicentennial Mini-Marathon
Starting 1:15 P.M.
7.6 Kilometers — Jack Rodgers

The bicentennial Olympics were held at Roosevelt Park.

THE TOWN OF HARRISON
AMERICAN REVOLUTION
BICENTENNIAL COMMITTEE

Invites You to a Cocktail Ball
To Celebrate

AMERICA'S 200th ANNIVERSARY

Saturday, November 20, 1976

6 pm to 11 pm

Harrison H.S. Gymnasium

$6.00 Per Person

Cocktails & Hors d'oeuvres

The bicentennial cocktail ball was held in the high school gymnasium.

Four

A NEW CENTURY UNFOLDS

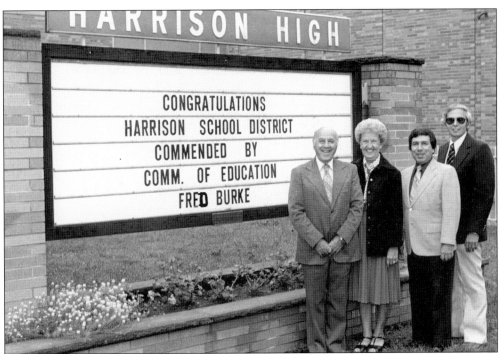

An award for excellence in education was bestowed on the Harrison school system in 1981 by Fred Burke, the New Jersey education commissioner. In front of the high school are, from left to right, O.J. DiSalvo, the superintendent of schools; B. Badginski, the principal of Lincoln School; V. Franco, the principal of Washington School; and Anthony Comprelli, the principal of the high school.

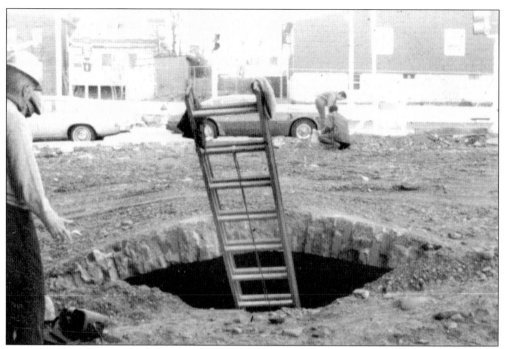

When breaking ground for Route 280, two cooling rooms used by the Trefz Brewery were discovered. Both rooms were 12 feet high and 12 feet wide and found near 128 Harrison Avenue. The Trefz Brewery was established in the 1850s.

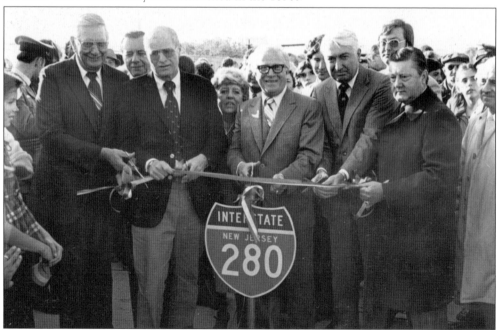

A ceremony commemorated the dedication of Route 280's final link at Stickel Bridge. Seen here are, from left to right, Mayor Henry Hill of Kearny, Congressman Frank Guarni, Gov. Brendan Byrne, Margaret McGuighan, Mayor Frank Rodgers, Lewis Gambaccin, Stanley Baranowski, Mayor Graham of East Newark, and the town engineer, Joseph Counari.

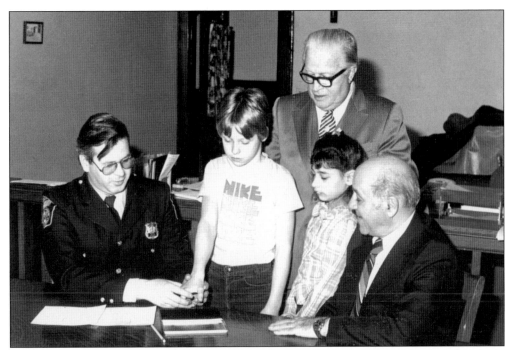

Harrison has always promoted child safety awareness. Here, Lincoln School children are fingerprinted in 1983. From left to right are Officer Russell Jackson, Ronnie Greenemier, Mayor Rodgers, Janine Alferes, and school superintendent O.J. DiSalvo.

In February 1983, Mayor Frank Rodgers was honored for his 36 years of service. He had been elected for his 19th consecutive term to the 32nd District. From left to right are O.J. DiSalvo, who was elected councilman in 1946; Congressman Peter Rodino; Mayor Rodgers; and Anthony Comprelli, the principal of the high school. DiSalvo has had quite a political career of his own. He is now a town councilman with over 50 years of experience.

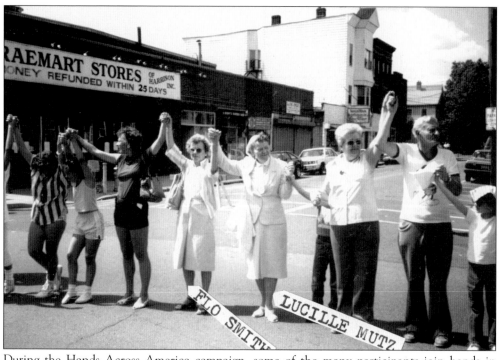

During the Hands Across America campaign, some of the many participants join hands in solidarity on May 25, 1985.

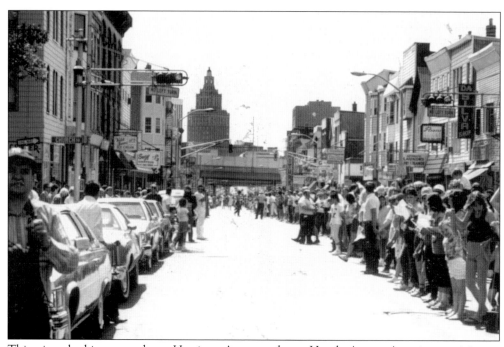

This view, looking west down Harrison Avenue, shows Hands Across America participants lining the main thoroughfare of the town.

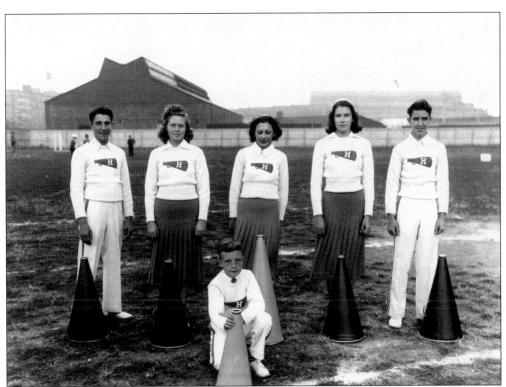

In a contrast of the ages, the photograph above shows the 1938 cheerleading squad, and the photograph to the right shows the 1950 Harrison High School cheerleaders. Note the coeducational squad with men present in 1938. Notice how, in the 12-year period between the two photographs, the uniforms changed and the hemlines on the girls' skirts were altered.

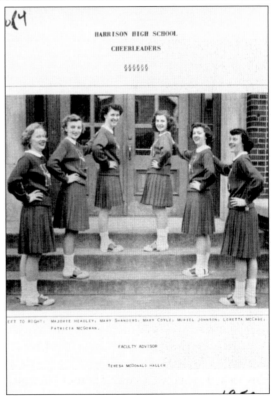

HARRISON HIGH SCHOOL
CHEERLEADERS

LEFT TO RIGHT: MAJORIE HEADLEY; MARY SHANDERS; MARY COYLE; MURIEL JOHNSON; LORETTA MCCABE; PATRICIA MCGORAN.

FACULTY ADVISOR

TERESA MCDONALD HALLER

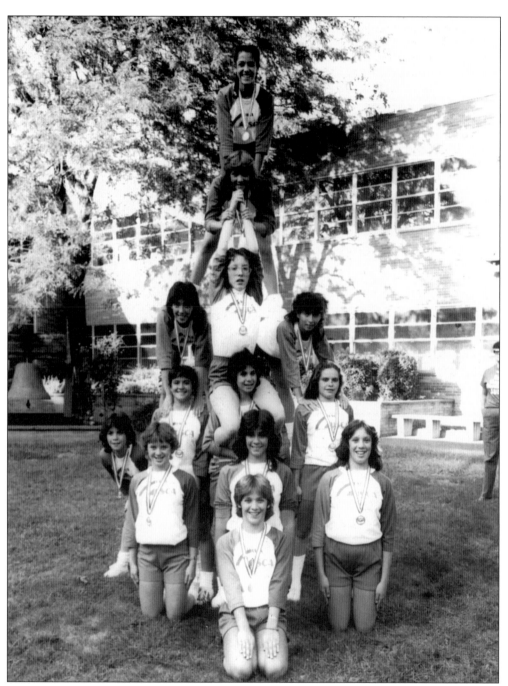

The Harrison High School cheerleading squad that captured the 1983 world championship poses by the high school. Coached by Nick Gregory, the squad members seen here are, from left to right, as follows: (first row) P. Carfagno; (second row) K. Woods, K. Callautti, and D. Ferreiro; (third row) M. Leonardis, J. Leon, A. Ferriero, and N. Diaz; (fourth row) B. Andrade, P. Boyd, and L. Wright; (second from top) L. Gohm; (top) J. Everisto. C. Young (not shown) was also on the squad. Gregory, listed in *American Cheerleading Who's Who,* still coaches the highly successful program today.

Mayor Rodgers stands in front of the town library under the banner honoring him for four consecutive decades of devoted service as Harrison's mayor.

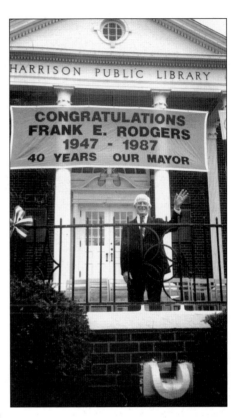

June 11, 1992

Mayor Rodgers,
Congratulations on another five years of faithful service to your community.

Sincerely,
Mary Dunsmuir

Even into the 1990s, Rodgers maintained his popularity, as reflected in a handwritten note from an appreciative citizen.

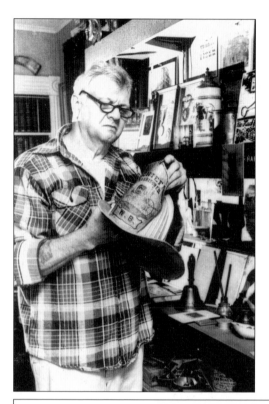

Henry Mutz is pictured in 1981. For many years, Mutz was the town historian and wrote the 1976 book *Harrison: The History of a New Jersey Town.* Today, Anthony Comprelli, assistant school superintendent, is the Harrison historian.

PREFACE

I had the privilege of knowing one of Harrison's oldest residents, Miss Willa Bower. Willa (whose mother was a Sandford) was born, lived, and died at the age of 92 in the same house at 35 Reynolds Avenue.

In 1968 Miss Bower gave this collector his first piece of Harrison memorabilia—a school bell which had been used by her cousin, Alice Morgan. In the 1860's, Miss Morgan had taught in Harrison's second school, located at the bend of Copper Mine Road (the corner of Bergen and Schuyler Avenues). She also taught in Washington Street School in the 1870's.

This bell roused my interest in the collecting of other items worthy of remembrance and led to this "History of Harrison." This book touches on highlights of the Town's history, which will hopefully satisfy the majority of readers, yet may serve as a guide to those who may wish to go more exhaustively into the subject.

—HENRY A. MUTZ

Seen here is part of the preface from Henry Mutz's 1976 book on Harrison's history. (From the collection of the late Henry Mutz.)

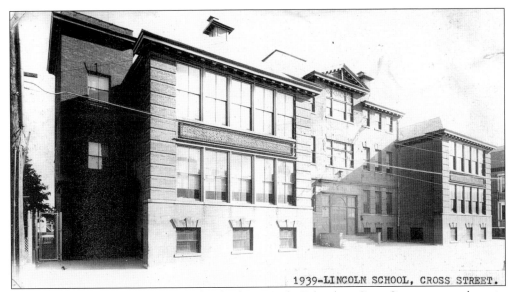

1939-LINCOLN SCHOOL, CROSS STREET.

Taking a look at the old Harrison schools, the Lincoln School on Cross Street is seen above in a 1939 view. Seen below is the old high school on Hamilton Street. That site served as the high school until 1962.

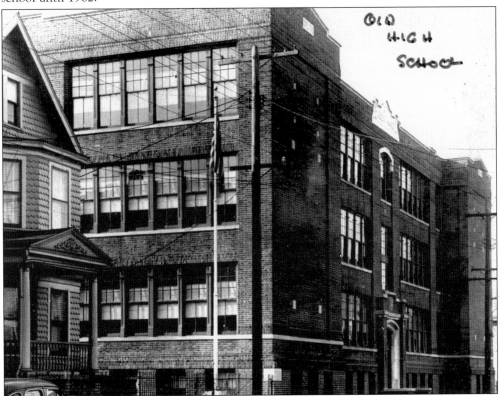

Construction has yet to commence, but the area is already fenced off at the northernmost section of Kingsland Avenue. This will be the site of the new high school. Included on the grounds will be a full outdoor athletic complex. Today, the high school teams play their games at John F. Kennedy Stadium, approximately a half-mile away from the school on Harrison Avenue. (Photograph by Karen Floriani.)

The annual Halloween parade is a tradition in the town of Harrison. Floats, bands, and marchers in costume parade down Harrison Avenue in this fall classic.

MEMORIAL DAY CEREMONIES and PARADE

Harrison, New Jersey

FRIDAY, MAY 29, 1981

Parade - 7:30 P.M.

Services - 8:15 P.M.
Roosevelt Park

 Remember
the Vietnam Veteran

This program for the 1981 Memorial Day parade especially remembered the Vietnam veterans.

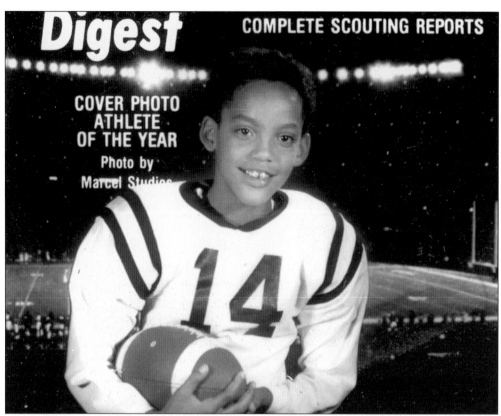

Digest COMPLETE SCOUTING REPORTS

COVER PHOTO
ATHLETE
OF THE YEAR
Photo by
Marcel Studios

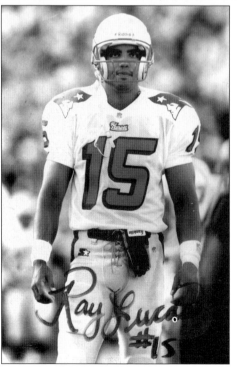

Clearly the most celebrated athlete in recent Harrison history, Ray Lucas is shown from his early days in peewee football to his days in the National Football League. Lucas was an all-around athlete and three-sport star at Harrison High School. He attended Rutgers University on a football scholarship, although his mother, Ellen, believed that "basketball was his best sport. He was as graceful as a dancer on the court." Following college, Lucas played in the NFL for the New England Patriots, New York Jets, and Miami Dolphins. Lucas always endeared himself to Patriot and then Jet coach Bill Parcells for his outstanding work ethic. Lucas never forgot his roots and frequently returned to the community, especially the high school, to visit.

This photograph is from the March 1981 issue of the *Blue Tide*, Harrison High School's student newspaper. The alumni award article chronicles the honoring of Harrison great Joe Reilly, a star running back for some of the school's outstanding teams in the late 1950s. In the picture, Reilly (second from the left) poses with several former teammates. They are, from left to right, William McFarland, Danny Cifelli, and Bob Flanigan. (Courtesy the Blue Tide.)

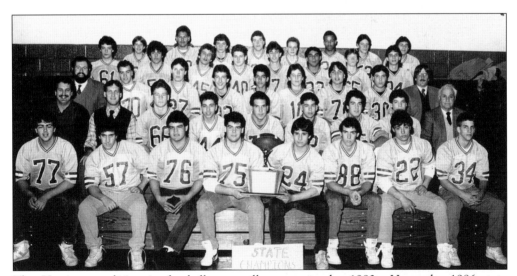

The Harrison tradition in football was still strong in the 1980s. Here, the 1986 state championship team displays their award in the gymnasium. In the second row on the far right is coach Ralph Borgess, a renowned figure in New Jersey high school football circles. In the third row on the far left is assistant coach Larry Manning, who still teaches at the high school.

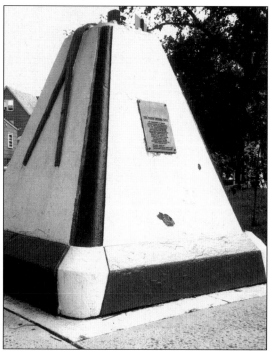

In front of the library is the Davis Diving Bell. It was used as far back as Revolutionary War times to retrieve parts of sunken vessels. Hiram Davis purchased the bell in 1825 for $5,000. With treasure recovered from sunken vessels, he earned enough money to build Drover's Inn in the late 1820s. (Photograph by Karen Floriani.)

Currently on the corner of Warren Street and Rodgers Boulevard is the town recreation center. Previously, this was the site of the old Warner Theatre. Years ago, when the theater was set to open, Monsignor Costello, pastor of Holy Cross Church, felt that all movies were immoral and openly criticized the theater. Mayor Rodgers felt that movies would be good recreation for the working man and proclaimed to Costello, "You take care of God, I'll take care of the people of Harrison." (Photograph by Karen Floriani.)

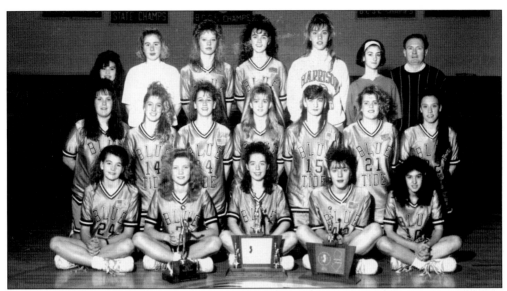

Going into the 1990–1991 season, Harrison had lost point guard Jodi Hill, who was headed to Pace on a basketball scholarship. Hill was one of the school's greatest athletes to play for the Lady Tide. With some expecting a drop-off, Harrison surprised fans by dominating the Bergin County Scholastic League National and winning the state championship. Seen here are, from left to right, the following: (front row) J. Purzycki, J. Zbikiewski, M. Ventura, D. DeRocker, and A. Melo; (middle row) M. Ferreiro, C. Dockery, D. Gilmore, K. McFadden, C. Ackerman, J. Valenti, and L. Villata; (back row) K. Labna, C. Keena, J. DeRocker, P. McKenna, B. Appleton, K. Varano, and coach Jack Rodgers.

Seen is the final box score from the state final at Monmouth College. In the semifinals, Harrison rallied from a late double-digit deficit to defeat Mendham in what coach Jack Rodgers termed "the Mendham miracle."

```
OFFICIAL NCAA BASKETBALL BOX SCORE    03-09-91   N. Long Branch, NJ
Licensed To: Monmouth                                        FINAL BOX

VISITORS: Manasquan 23-6              Group II Championship
NO PLAYER               FG FGA  3P 3PA  FT FTA  OR DR TOT  PF PTS  A TO BLK S  MIN
15 Jen Kackos            4  11   0   0   8  10   1  1   2   3  16   1  7   1 3   23
22 Sharon Grasbee        0   3   0   0   0   0   0  2   2   0   0   0  5   1 0   24
55 Janet Beaver          9  13   0   0   0   2   8  7  15   2  18   2  1   0 3   21
12 Megan Manoney         0   1   0   0   0   0   1  1   2   3   0   2  7   0 0   29
25 Dara Hahn             4  18   0   1   3   8   4  7  11   4  11   3  8   0 4   24

44 Pia Houseal           1   1   0   0   0   0   0  1   1   0   2   0  0   0 0    4
30 Sarah Jones         DNP-
20 Shannon Bresnahan    DNP-
35 Kate Kennedy         DNP-
40 Heidi Gamer           1   2   0   0   0   0   1  0   1   3   2   0  0   0 0    0
32 Judy Bohrer          DNP-
50 Casey Schofield      DNP-
   TEAM                                          2  2   4           0

   TOTALS               19  49   0   1  11  20  17 21  38  15  49   8 28   2 10  125

TOTAL FG % 1st Half 30.8  2nd Half 60.0  OT 41.2  Game 38.8  DEADBALL
3 PT FG % 1st Half  0.0   2nd Half  0.0  OT  0.0  Game  0.0  REBOUNDS  3
   FT % 1st Half 50.0     2nd Half 66.7  OT 55.6  Game 55.0

HOME:   Harrison 25-5
NO PLAYER               FG FGA  3P 3PA  FT FTA  OR DR TOT  PF PTS  A TO BLK S  MIN
35 JoAnne DeRocker        5   7   0   0   1   2   5  5  10   4  11   0  2   0 5   21
40 Michele Ferriero       4  11   0   0   9  12   3  4   7   4  17   0  3   1 3   24
14 Chrissy Dockery        4  11   0   0   2   4   1  1   2   2  10   6  8   0 3   24
22 Lisa Villatta          4   9   0   0   1   4   1  6   7   2   9   6  3   0 2   24
34 Danielle Gilmore       5  11   0   0   0   0   3  1   4   1  10   1  5   0 3   24

15 Chastity Ackerman    DNP-
23 Kathy McFadden         1   1   0   0   1   2   0  0   0   1   3   0  1   0 0    7
33 Patti McKenna        DNP-
10 Andre Melo           DNP-
24 Jen Purzychi         DNP-
21 Janet Valenta        DNP-
04 Marge Ventura        DNP-
42 Donna DeRocker       DNP-
   TEAM                                          0  2   2           0

   TOTALS               23  50   0   0  14  24  13 19  32  14  60  13 22   1 16  124

TOTAL FG % 1st Half 38.5  2nd Half 27.8  OT 68.4  Game 46.0  DEADBALL
3 PT FG % 1st Half  0.0   2nd Half  0.0  OT  0.0  Game  0.0  REBOUNDS  3
   FT % 1st Half 66.7     2nd Half 66.7  OT 44.4  Game 58.3

Technical Fouls: 0
Attendance:

OFFICIALS:                   SCORE BY PERIODS   1   2  OT  OT  OT       FINAL
Mary Beth Kirschling/George Evinski   Manasquan  12  14  15   4          49
George Evinski                        Harrison   14  14  19  11          60

         This report has been produced by STATMAN II (ta) 2.57.FCW
```

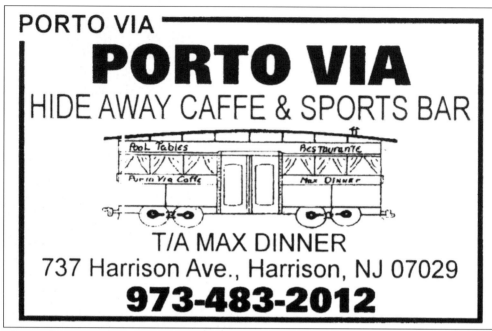

PORTO VIA

PORTO VIA
HIDE AWAY CAFFE & SPORTS BAR

Pool Tables Restaurante

Por in Via Caffe Max Dinner

T/A MAX DINNER
737 Harrison Ave., Harrison, NJ 07029
973-483-2012

This card is for Porto Via, which is sublet as a combination of Max's Diner and a sports bar. The establishment is divided down the middle. To the left is a softly lit bar, and to the right is the diner.

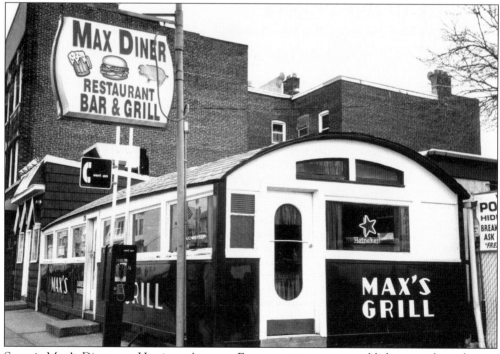

Seen is Max's Diner, on Harrison Avenue. For years, it was an establishment where factory workers would grab a good bite at lunch. Today, it is a combination diner and sports bar. (Photograph by Karen Floriani.)

This portrait shows John Rodgers, longtime fire chief.

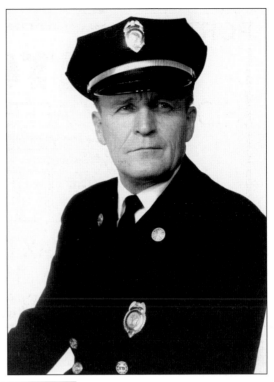

Chief Rodgers

A Fireman's Fireman Will Be Missed for His Concern and Profesionalism

"A woman came up to us at the wake and told us that he had once saved her son's life, and we never knew anything about it."

Such was the way Jack J. Rodgers described his late father, former Harrison Fire Chief John Rodgers – "a guy who just thought he was doing his job."

It was this approach to firefighting that led to the tremendous outpouring at Chief Rodgers' wake, a tribute in the form of crossed aerial ladders in front of the Kearny Fire Department, and an equally impressive tribute by the Harrison Fire Department in the form of the presence of an Honor Guard throughout the services.

Chief Rodgers' co-worker for 38 years, former chief clerk Peter Higgins Sr., had equal praise.

"He was a good man and a good administrator who could still put the helmets and boots on," commended Mr. Higgins.

As current Harrison Fire Chief Louis Nazzaro suggested, Chief Rodgers' spirit lives on, as Chief Nazzaro has tried to incorporate the late chief's advice to him into the current department.

"The chief was a fireman's fireman. He was a professional, and acted as such," concluded Chief Nazzaro. He will surely be missed.

Seen is a tribute to the memory of John Rodgers, who served the Harrison community as a fireman for 38 years and as chief for the last 15 of those years. He retired from service in 1985 and passed away in 1997. (Courtesy the Observer, Kearny, New Jersey.)

95

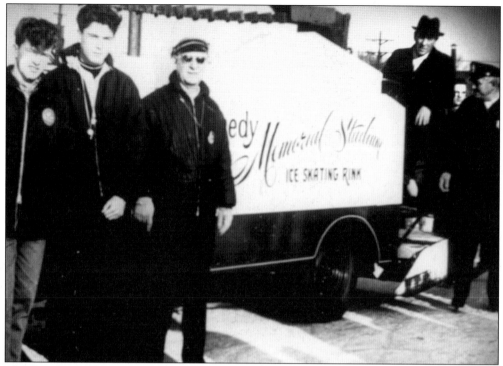

The first Zamboni in town was used on the ice rink at John F. Kennedy Stadium.

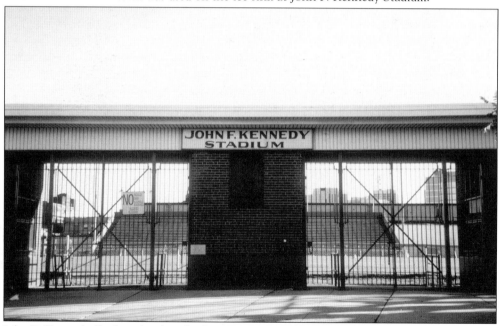

John F. Kennedy Stadium borders the Passaic River, and Newark's skyline is seen in extremely close proximity from the western side of the field. Besides hosting football and soccer games, the stadium has been used as an ice-skating rink in the past. The stadium was formerly named for Mayor Rodgers, who himself later worked to have the name changed to John F. Kennedy Stadium to honor the former president. (Photograph by Karen Floriani.)

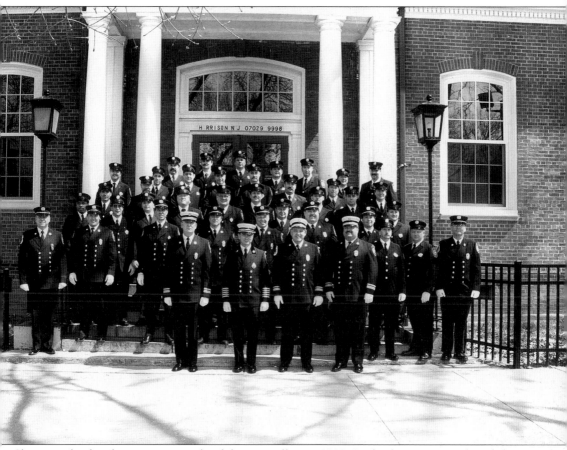

Shown is the fire department outside of the post office in 2002. In the front row are, from left to right, Ted Glancey (department chief), Louis Nazzaro (chief), Mike DiSalvo (department chief), and Tom Dolaghan (department chief and current chief).

The old Crucible Steel plant was on Rodgers Boulevard near the Passaic River. The site will soon be cleared for the MetroStars' new soccer stadium. (Photograph by Karen Floriani.)

The PATH station was located across the street from Crucible Steel. To this day, the station is an extremely accessible and popular place for commuters to get the PATH trains to New York City. (Photograph by Karen Floriani.)

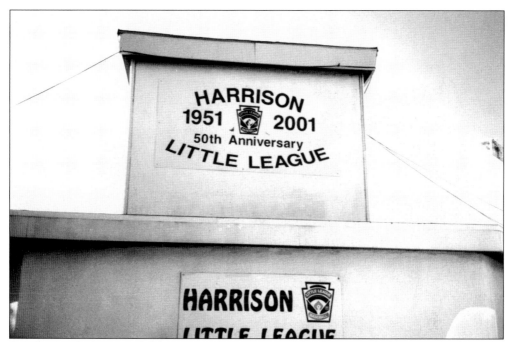

At the Little League field on Harrison Avenue, the banner commemorates the 50th anniversary of Little League in Harrison. (Photograph by Karen Floriani.)

Seen is the roster book for the School and College Officials Association (SCOA). This association of soccer officials began in a tavern in Harrison. The chapter began with 13 charter members and has well over 200 today. Involved are soccer officials who referee at the recreation, high school, and college levels.

November 14, 1989, was proclaimed Frank Rodgers Day in Essex County. The tribute was special considering that Rodgers served as mayor in a town located in Hudson County. The proclamation lists many of the mayor's outstanding achievements.

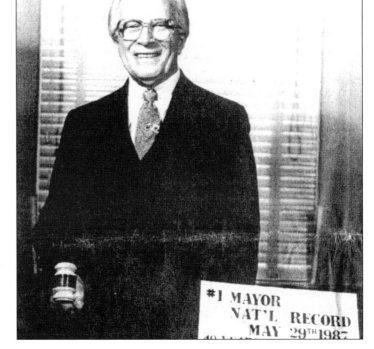

#1 MAYOR
NAT'L RECORD
MAY 29TH 1987

The *Observer* ran an obituary and death notice for Frank Rodgers. This photograph accompanied the February 2000 story. (Courtesy the Observer, Kearny, New Jersey.)

Seen is the Harrison High School girls basketball program for Senior Night in 1996. The program included not only the girls outstanding contributions on the court but also their grade point averages, showing their excellence in the classroom.

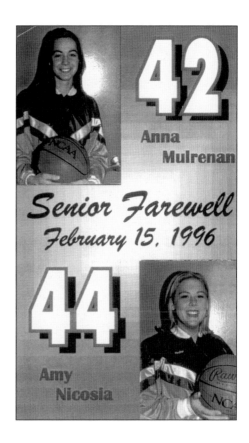

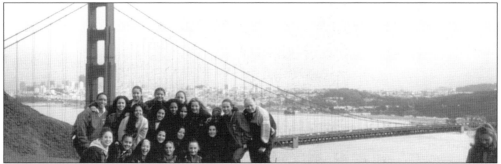

Under the guidance of coach Jack Rodgers, the Harrison High School girls basketball team has set a high standard of excellence. Rodgers moved from the boys to the girls team to resurrect the program in the early 1980s. He did it with work ethic and full-court man-to-man pressure defense. "Back then girls teams played zone," Rodgers recalled. "When we came out man to man they thought we were cheating." One of the special parts of his program is travel. His teams have been to Florida, Arizona, Ireland, and, as seen here, San Francisco. In each of their many travels, they play teams from that area and take in a special cultural and athletic experience. Here, they pose with Rodgers (on the right) at San Francisco's Golden Gate Bridge in December 2002.

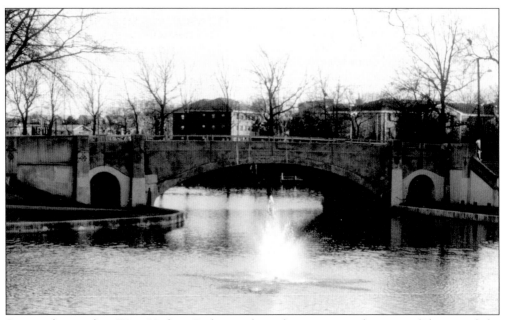

Seen is the pond in West Hudson Park on a late afternoon in early spring. (Photograph by Karen Floriani.)

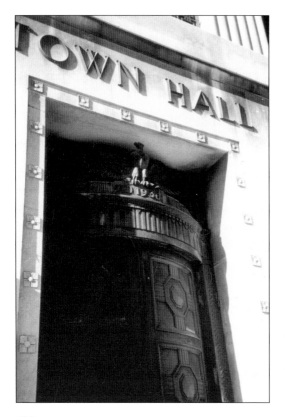

The town hall is located just off Harrison Avenue. The ornate door of the building often gets a great deal of praise from first-time visitors. (Photograph by Karen Floriani.)

Seen are the rosters of the final-four teams from the 2001 New Jersey Group I championships. The roster was part of the state championship program. The Blue Tide successfully defended their title in 2002. The team was undefeated but had one tie, with Kearny. Ironically, Harrison coach Mike Rusek played his high school soccer at Kearny.

HARRISON HIGH SCHOOL
Harrison, NJ
ROSTER

NO.	NAME	POS.	GR.
00	Viana, Raphael	GK	So.
1	DaSilva, Jorge	GK	Sr.
2	Olivares, Piero	D	So.
3	Perez, Javier	D	Sr.
4	Carrera, Luis	D	Jr.
5	Morgado, Henrique	D	Jr.
6	Fernandez, Benito	MF	Sr.
7	Barrantes, Michael	MF	So.
8	Acuna, William	D	Sr.
9	Ranilla, Italo	F	So.
10	Gonzalez, Immer	MF	Jr.
13	Sabia, Anthony	D	So.
14	Acuna, Cristian	MF	Fr.
15	Vera, Juan	MF	Jr.
16	Stancov, Rui	MF	Jr.
17	Macedonio, Martin	MF	Jr.
18	Moron, Carlos	MF	Jr.
19	Alonso, Nestor	F	So.

Conference: **BCSL**
Nickname: **Blue Tide**
Colors: **Blue & White**

Supt. of Schools: **Mr. O. John DiSalvo**
Principal: **Mr. Ronald Shields**
Athletic Director: **Mr. Jack Rodgers**
Head Soccer Coach: **Mr. Michael Rusek**

**NORTH I
GROUP II**

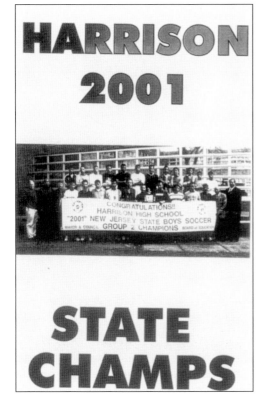

This program from Harrison High School's 2001 state championship team was produced by the high school to commemorate the team's title.

This street fair is a regular event that closes off most of Harrison Avenue for a weekend each June. (Photograph by Karen Floriani.)

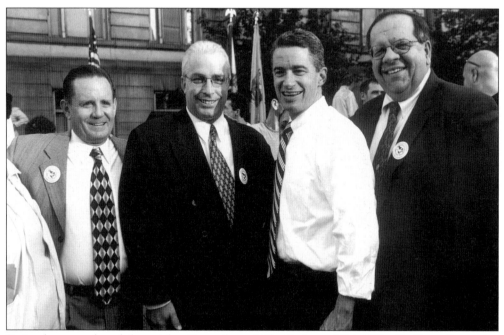

Posing here are, from left to right, Councilman Mike Rodgers (Third Ward), Councilman Art Pettigrew (First Ward), Gov. James McGreevey, and Mayor Ray McDonough.

The McClave lumber company, as shown in this recent photograph, is still in operation today on Harrison Avenue. (Photograph by Karen Floriani.)

Pechter's was near the old Worthington plant. For years, it was a popular outlet for fresh-baked bread products. The enterprise is now also known as the Harrison Baking Company. (Photograph by Karen Floriani.)

Tom Diamond was the owner of the Ship Ahoy bar in Harrison. The ownership has changed hands, and the tavern has changed names to date. Diamond was a former performer on vaudeville who is said to have encouraged his friend, Bob Hope, to take up golf.

Diversity is a major part of present-day Harrison. Above is the insignia of the Polish National Home, located on Cleveland Avenue. Shown side by side on Harrison Avenue below are Los Valles and O'Donnell's Pub. (Photographs by Karen Floriani.)

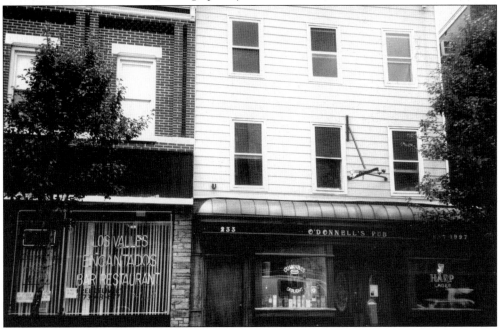

World Trade Center Memorial

Dedication Ceremony

Thursday, September 11, 2003

7:00 pm in the evening

at the

Roosevelt Park (Library Park)

Seen here is the program for the dedication of the World Trade Center monument. The monument, which consists of remains of the World Trade Center, sits just off Harrison Avenue in front of Roosevelt Park by the library.

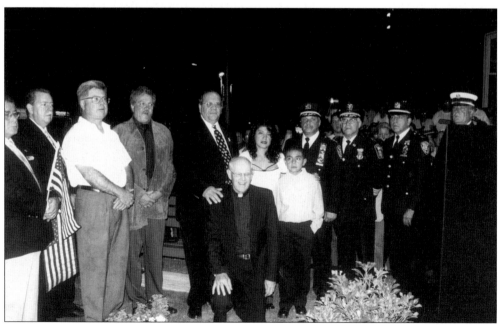

During the dedication ceremony, Mayor Ray McDonough stands behind and stretches his hand on the shoulder of a priest offering prayer. To the right of McDonough are a widow and son from one of the victims of the tragedy of September 11, 2001.

This view shows the steel structure that was recovered from the debris of the World Trade Center and donated to Harrison. (Photograph by Karen Floriani.)

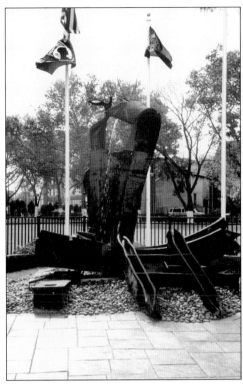

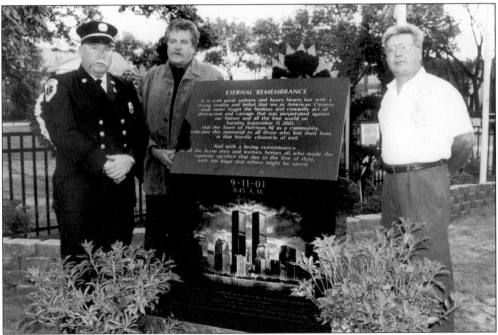

Fire Captain James Woods, chairman of the Harrison World Trade Center Monument Committee, stands at the extreme left in front of the monument, created from World Trade Center remains. Standing next to Woods is Anthony Chiccino, the structural designer for the monument. Councilman Michael Dolaghan is on the far right.

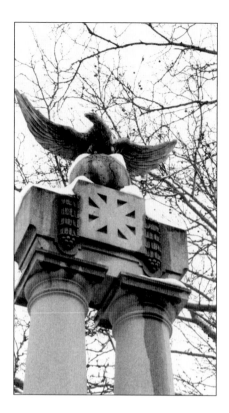

The World War I monument is located near the library. Seen here is the top of the monument. (Photograph by Karen Floriani.)

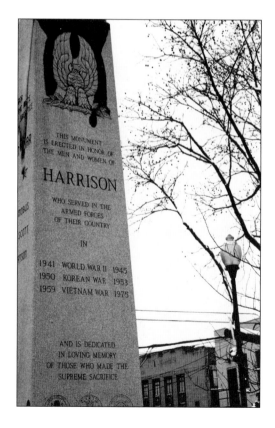

Several feet from the World War I monument is this tribute to the veterans of World War II, the Korean War, and Vietnam. (Photograph by Karen Floriani.)

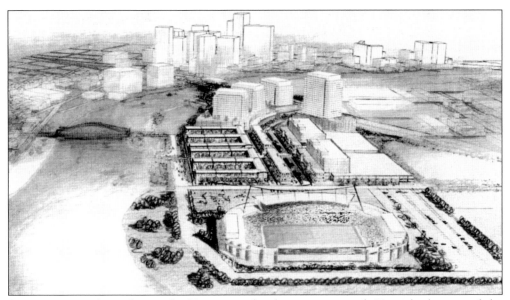

Seen is an artist's rendition of a Harrison redevelopment proposal. Near the bottom of the drawing is the proposed MetroStars stadium near the Passaic River on the site of the old Crucible Steel complex.

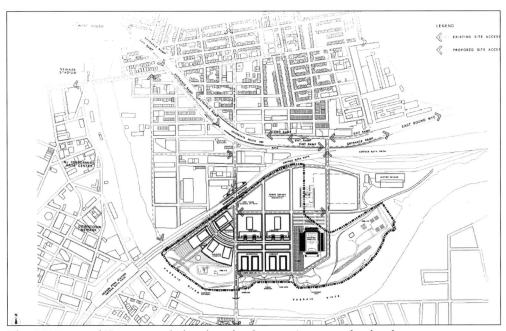

This 2003 map of Harrison includes plans for the town's proposed redevelopment.

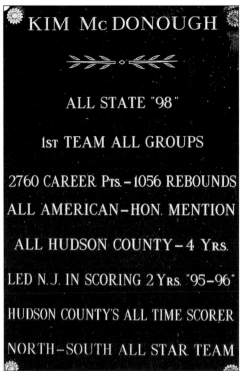

KIM McDONOUGH

ALL STATE "98"

1ST TEAM ALL GROUPS

2760 CAREER PTS. – 1056 REBOUNDS

ALL AMERICAN – HON. MENTION

ALL HUDSON COUNTY – 4 YRS.

LED N.J. IN SCORING 2 YRS. "95–96"

HUDSON COUNTY'S ALL TIME SCORER

NORTH–SOUTH ALL STAR TEAM

The all-time leading scorer for Harrison High School's basketball program (male and female) is Kim McDonough. She shattered the scoring record held by Ray Lucas. McDonough went on to earn a basketball scholarship and play at St. Peter's College in Jersey City. McDonough's outstanding career is briefly chronicled in the plaque shown here.

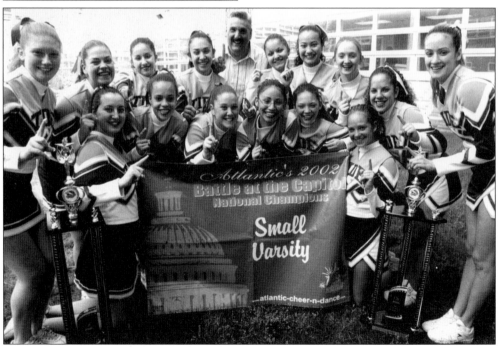

Thank-you cards were distributed by the 2002 Harrison cheerleaders. The girls, coached by veteran mentor Nick Gregory (in the center of the last row), won the 2002 national championship. The tricaptains are K. Kulbatski (far left), M. Raposo (kneeling on the bottom left), and S. Weir (far right).

Five

HOUSES OF WORSHIP

Seen is the window of the former Wesley Methodist Episcopal Church, now the Davis Memorial Church. The windows of the church were donated by the Davis family. (Photograph by Karen Floriani.)

This 1920s view shows the Davis Memorial Church. The congregation began in the 1850s as the Wesley Methodist Episcopal Church and is the oldest church organization in Harrison.

¿¿PODRA

✝

USTED

CREER??????

*¡¡La oferta más grande
en el mundo
es gratis!!*

Porque por gracia sois salvos por medio de la fe; . . . pues es don de Dios. (RV60)

Efesios 2.8

•

This current bulletin for the Davis Memorial Church notes services in Portuguese. Today, services are offered at the church in English and Portuguese, which reflects the ethnic diversity of the community.

This is an artist's sketch of Holy Cross Church. The sketch was not dated but was probably done in the early 20th century. Founded in 1863, Holy Cross was the first Roman Catholic place of worship in West Hudson.

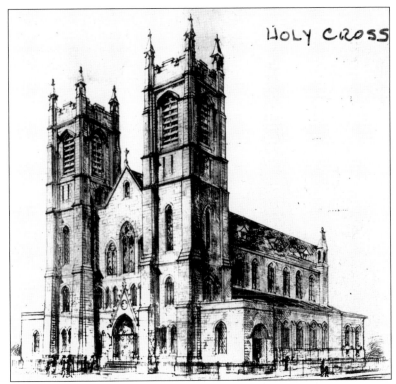

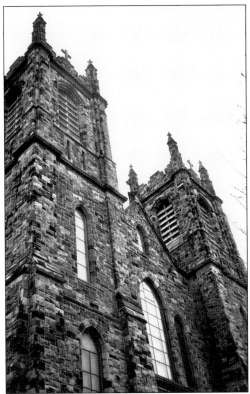

This 2003 photograph of Holy Cross Church was taken almost directly in front of the church and fully brings out the height and architecture of its steeples. (Photograph by Karen Floriani.)

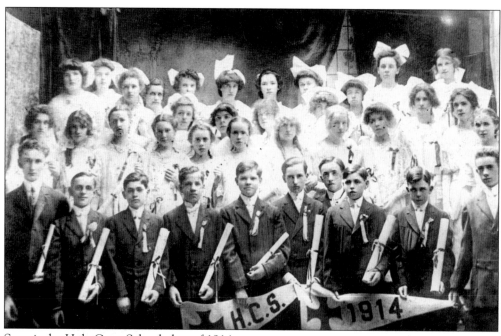

Seen is the Holy Cross School class of 1914.

This Christmas note from 1917 was written by Francis (Frank) Rodgers to his parents. Rodgers would later go on to have a long and fabulous political career in Harrison. At this date, however, he was a student at Holy Cross School. The parochial school was one of two supported by parishes in Harrison.

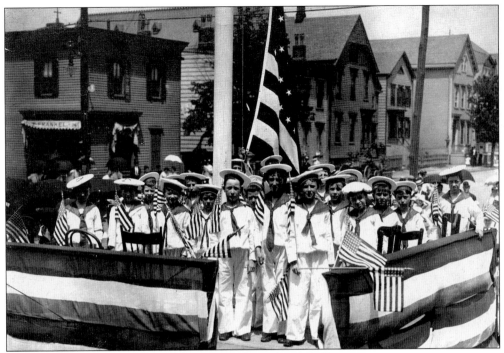

Seen is the opening of the Holy Cross School parade in 1915.

This recent Holy Cross School view was taken from Frank Rodgers Boulevard. To the right of the school are Harrison Avenue and Holy Cross Church. (Photograph by Karen Floriani.)

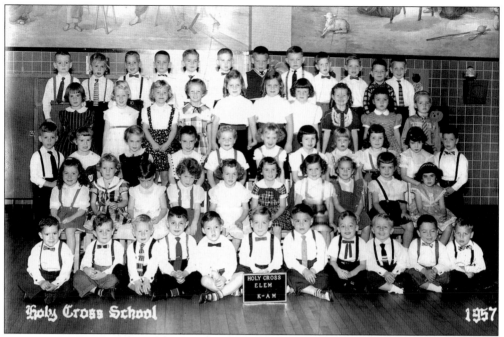

The Holy Cross School kindergarten class of 1957 is seen here.

This Holy Cross School diploma was issued in June 1921 to Mary Rodgers, the sister of Frank Rodgers.

Holy Cross Parish
16 Church Square, Harrison, New Jersey

Alleluia. Alleluia!

Holy Cross, a Roman Catholic church, also serves its ethnically diverse congregation. To the right is the cover of the church bulletin for Easter Sunday. Below is an inserted page from the same bulletin printed in Portuguese. (Courtesy Holy Cross Church.)

BOLETIM PAROQUIAL - IGREJA DE HOLY CROSS
Domingo de Páscoa

Missa Dominical
Celebrada neste Domingo por pelas intenções da Novena da Páscoa.

Ministros extraordinários da Eucaristia
Neste Domingo: Antonio e Isabel Silva
Próximo Domingo: Maria das Neves e Fernanda Batel
Leitores
Neste Domingo: Candida Vieira e Celeste Andrade
Próximo Domingo: Antonio e Cecilia Sarabando
Comentarista
Neste Domingo: Fernanda Batel
Próximo Domingo: Ana Sarabando
Acólitos:
Neste Domingo: Albert Silva, José Marques e Judite Ferrão
Próximo Domingo: Steven Henriques, Brian Carlos e Michael Barbosa

FELIZ PÁSCOA
O Monsenhor Gil Christ, as irmãs e o Pe. Paulo desejam a todos os paroquianos uma Santa e Feliz Páscoa. Que o Senhor Jesus possa, verdadeiramente, ressuscitar em vossos lares. Ao final desta Missa proceder-se-á ao beijo da Cruz, como rito breve da Visita Pascal.

AGRADECIMENTOS
Nossos mais sinceros agradecimentos aos membros da Sociedade Nossa Senhora de Fátima pelo donativo oferecido à Paróquia de Holy Cross como resultado da realização da festa do cozido à portuguesa.

PRIMEIRAS COMUNHÕES
As crianças matriculadas no 2° ano da catequese em português estarão recebendo o Sacramento da Eucaristia no dia 4 de Maio, Domingo, dentro da Missa das 9:00 da manhã. A primeira confissão e o ensaio para a 1ª Comunhão será realizado na quinta-feira, dia 1° de Maio às 7:30pm na Igreja.

PROCISSÃO A NOSSA SENHORA
MAY FEST
No dia 2 de Maio, sexta-feira, às 7:30pm estaremos saindo em procissão em honra a Nossa Senhora como abertura da festa paroquial beneficente do May Fest, celebrada no dia 3 de Maio, sábado. Traga sua família e venha participar conosco.

Sagrada Familia
1 *Esta semana na casa de Fernando Silva*
 Próxima semana na casa de Maria Baldaia
2 *Esta semana na casa de Maria Cerqueira*
 Próxima semana na casa de Pedro Pereira
3 *Esta semana na casa de João Antunes*
 Próxima semana na casa de Rosa Rafael
4 *Esta semana na casa de Ana R. Barbosa*
 Próxima semana na casa de Maria Leitão

SOCIEDADE NOSSA SRA. DE FÁTIMA
NOTÍCIAS
Vela de Nossa Senhora: *estará acesa em ação de graças a Nossa Senhora a pedido de Emília Ferreira.*
Recitação do terço: *Recitado todos os Domingos às 8:30am e todas as quartas-feiras após a Missas das 7:30pm. Qualquer pessoa presente poderá fazer a recitação do terço.*
Bolsas de estudos: *Os filhos dos membros da Sociedade que vão frequentar o colégio, e interessados, devem pedir-nos a aplicação e preenche-la para podermos oferecer a bolsa no valor de $500. cada.*
Informativo: *O ensaio do coro em português é às 8:00pm, todas as segundas-feiras. Qualquer pessoa jovem ou adulto será sempre vem-vinda.*

◆

"A Festa da Ressurreição"
A morte, ao longo da nossa existência, é encarada como inevitável e sempre prevalecendo sobre a vida.

A cena relatada pelo Evangelho recorda-nos muitas situações vividas nos nossos dias em muitas regiões em que a morte é dominante e o silêncio parece comemorar a sua vitória. O poder, a força, a guerra, a discriminação, etc... parecem destruir e esmagar a força da vida. E o homem sente-se vencido e oprimido pelas forças do mal.

Mas, eis que uma mulher dirigiu-se ao túmulo de Cristo testemunhnando que o mesmo se encontrava vazio e deu o primeiro sinal da revolução operada por Deus na manhã de Páscoa, o primeiro dia da semana.

Esta mesma mulher, hoje para nós, é a Igreja que continualmente anuncia a todas as linguas, povos, etnias e nações que hoje não é dia de derrota, mas dia de vitória. A morte, e aquele que a dominava, foram vencidos. Hoje novo sol brilha; o brilho da vida da graça oferecida gratuitamente por Cristo a todos aqueles que crêm no Seu nome e naquele mesmo poder de Sua Ressurreição.

Feliz Páscoa a todos!
✝Pe. Paulo Frade

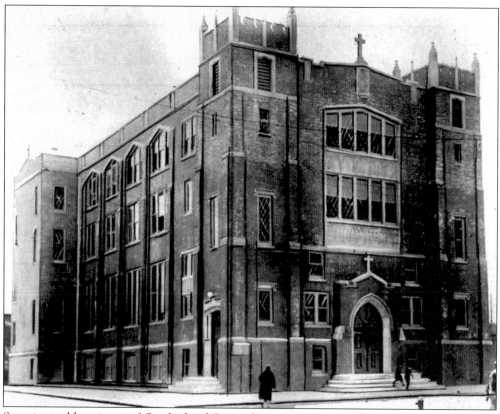

Seen is an older picture of Our Lady of Czestochowa Roman Catholic Church. The church is located about a block and a half south of Holy Cross and has drawn the town's Polish population for a number of years.

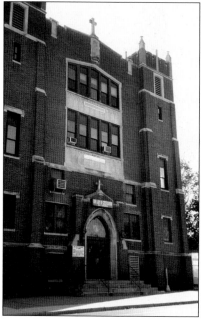

This is a current view of Our Lady of Czestochowa. The church was first instituted in 1908 on Cleveland Avenue. Services were held there until 1916, when the old Holy Cross School was taken over at Third and Jersey Streets. Fires in 1927 and 1929 necessitated the building of a combination church and school. (Photograph by Karen Floriani.)

This Madonna statue is located outside of Our Lady of Czestochowa. The Madonna sets a solemn tone for those arriving to church. (Photograph by Karen Floriani.)

The Year Of The Rosary

On October 16th, the 24th anniversary of his election as Supreme Pastor, Pope John Paul II proclaimed October 2002 to October 2003 to be The Year of the Rosary. In doing so the Holy Father added five mysteries to the traditional fifteen. They are the five "luminous" mysteries: *1. The Baptism of Jesus, 2. The First Miracle of Jesus at Cana, 3. The Proclamation of the Kingdom of God, 4. The Transfiguration, and 5. The Institution of the Eucharist,* which are ordinarily to be prayed on Thursday. They may be inserted after the joyful, and before the sorrowful mysteries. In his Apostolic Letter, Rosarium Virginis Mariae, Pope John Paul II wrote "The history of the Rosary shows how this prayer was used... at a difficult time for the Church... today we are facing new challenges. Why should we not once more have recourse to the Rosary, with the same faith as those who have gone before us? The Rosary retains all its power and continues to be a valuable pastoral resource for every good evangelizer."

Rok Różańca Świętego

Dnia 16-go października, w 24-tą rocznicę wyboru na Stolicę Apostolską, Papież Jan Paweł II ogłosił rok od Października 2002 do Października 2003, Rokiem Różańca Świętego. Przy tej okazji Ojciec Święty dodał 5 tajemnic Różańca Świętego do tradycyjnych 15-tu. Jest to pięć tajemnic rzucających światło na: *1. Chrzest Pana Jezusa w Jordanie, 2. Objawienie siebie na weselu w Kanie, 3. Głoszenie Królestwa Bożego i wzywanie do nawrócenia, 4. Przemienienie na górze Tabor, 5. Ustanowienie Eucharystii,* które normalnie powinny być odmawiane w każdy czwartek. Mogą być odmawiane po Tajemnicy Radosnej i przed Tajemnicą Bolesną. W liście apostolskim „Rosarium Virginis Mariae" Papież Jan Paweł II napisał „Historia Różańca pokazuje, w jakim celu tę modlitwę używano... w czasach trudnych dla Kościoła ... Dzisiaj jesteśmy w obliczu nowych problemów. Dlaczego więc nie powinniśmy się ponownie zwrócić do Różańca, z taką samą wiarą jak nasi przodkowie? Różaniec w dalszym ciągu posiada taką samą siłę i nadal spełnia ważną rolę duszpasterską jako źródło dla każdego głosiciela Ewangelii. "

Diversity again comes into play in servicing the congregation. *The Year of the Rosary* bulletins are available at Our Lady of Czestochowa in both English and Polish. (Courtesy Archdiocese of Newark, New Jersey.)

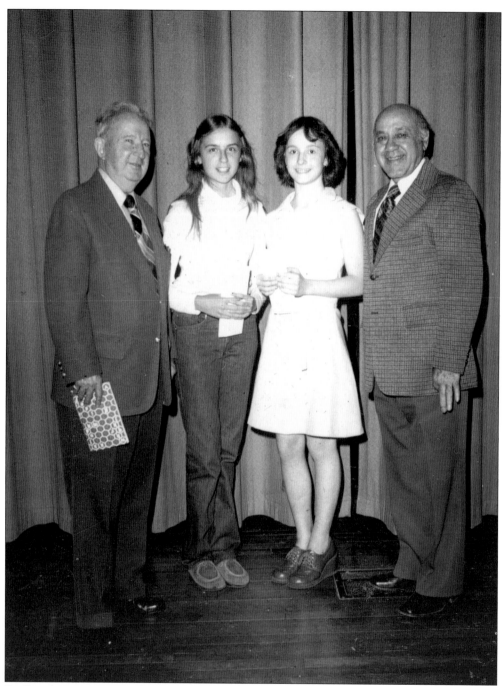

Spelling bees are a part of grammar school, but the competition at Our Lady of Czestochowa School in the late 1970s brought some recognition. From left to right are Martin Honan, superintendent of schools; Laura Malley; Yolanda Ruthowski; and O.J. DiSalvo, assistant superintendent of schools.

This is to Certify,

That _Miss. Mary. B. Sanford_

Is a Member of the Sunday School

connected with the _Belleville_

METHODIST EPISCOPAL CHURCH.

_____ Supt.

_____ Secy.

Harrison 1857

Seen is a Sunday school certificate from the middle of the 19th century. The holder of the certificate was connected with a church in Belleville, but the document appeared to originate and was signed in Harrison.

This Sunday school hymn sheet was believed to be used by the Sanford family in 1853.

This is another selection of hymns used in Harrison Sunday school in the middle of the 19th century.

PROGRAMME
OF
EXERCISES
OF THE

HARRISON SUNDAY SCHOOL,
September 7, 1855.

1. SINGING.

Lord, we are spared again to meet
 On this rejoicing day !
To bow before thy mercy-seat,
 To praise thee. and to pray.

To Jesus every eye we raise,
 On him for mercy rest;
Young children, in his mortal days
 He folded to his breast.

Many, since last we gather'd here,
 Have pass'd away like flowers;
Perhaps, before another year,
 Their dwellings may be ours!

Lord, to thine open arms we fly,
 And seek our safety there;
Then shall we have no fear to die,
 If though our hearts prepare.

2. PRAYER.
3. ADDRESS, - by Anthony Brill
4. ADDRESS, - by Charity Williams
5. ON THE DEATH OF 2 SCHOLARS, by Charles Shepherd
6. JACOB'S REPOSE, - by Bridget Lavine
7. HOPE OF HEAVEN, - by James Earl
8. HARVEST, - by Sarah E. Boyd
9. ORIGIN OF A RIVER, - by George Fulliger
10. BLIND BOY, - by Mary A. Van Emburgh
11. WINTER, - By Robert Dukes
12. WHAT I LOVE, - by Elizabeth Shepherd
13. TO-MORROW, - by Thomas Clark
14. LITTLE STAR, - by Alice Van Amburgh
15. STAR OF BETHLEHEM, Julia A. Van Emburgh
16. GREAT ORATOR, - by James Williams
17. THE CHILD-ANGEL, - by Emmorillas Hoyt

This program of exercises for Sunday school dates from the middle of the 19th century.

18. SINGING,

I want to be an angel,
 And with the angels stand,
A crown upon my forehead,
 A harp within my hand ;
There, right before my Saviour,
 So glorious and so bright,
I'd wake the sweetest music,
 And praise him day and night.

I never should be weary,
 Nor ever shed a tear,
Nor ever know a sorrow,
 Nor ever feel a fear;
But blessed, pure, and holy,
 I'd dwell in Jesus' sight,
And with ten thousand thousand
 I'd praise him day and night.

I know I'm weak and sinful,
 But Jesus will forgive,
For many little children
 Have gone to heaven to live ;
Dear Saviour, when I languish,
 And lay me down to die,
O send a shining angel
 To bear me to the sky.

O! there I'll be an angel,
 And with the angels stand,
A crown upon my forehead,
 A harp within my hand ;
And there before my Saviour,
 So glorious and so bright,
I'll join the heavenly music,
 And praise him day and night.

19. SPEAK GENTLY, - by Emma R. Conley
20. PRETTY FLY, - by John H. Boyd
21. TWO SWALLOWS - by Rachel Earl
22. CURFEW, - by Margaret Seely
23. LITTLE CLARA, - by Amanda Shepherd
24. THE SHIP, - by Abram Hewitt
25. THE COMPARISON, - by Charles Hewitt
26. THE SAILOR BOY, - by Lewis Williams
27. THE ASS AND WOLF, - by Robert Clark
28. BLIND WILLIE, - by Emily Morgan
29. GOOD RULE, - by Charles Shepherd
30. THOUGHTS, - by Harriet Stanford
31. THE TRADESMAN, - by Levi Campbell
32. PET RABBIT, - by Susan Earl
33. LITTLE GIRL'S LAST WORDS, by Elizabeth Shepherd
34. FIELD OF GILBOA, - by Emmorillas Hoyt
35. DIALOGUE, - by { Anthony Brill / Lewis Helfry
36. WHEN I WAS YOUNG, - by Mariah Hewitt
37. RAINBOW, - by { Charity Williams / Rachel Earl / Julia A. Van Emburgh / Alice Morgan / Amanda Shephard / Tacie Condit / Emma R. Conley
38. PRESENTATION OF CERTIFICATES,
 By REV. E. H. STOKES.
39. COLLECTION. 40. DOXOLOGY.
41. BENEDICTION. 42. SE RAFRAICHIR.

DOUGLASS & STARBUCK, PRINTERS, 125 MARKET ST, NEWARK, N. J.

Seen to the left is a view of St. John's Lutheran Church, on Davis Avenue. Below is a full view of the church. The old church was built in 1914. The new building was constructed on the same site in 1928, and the church has remained the same to date. (Photographs by Karen Floriani.)

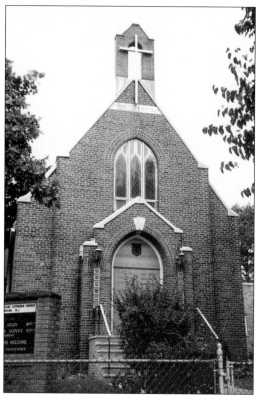

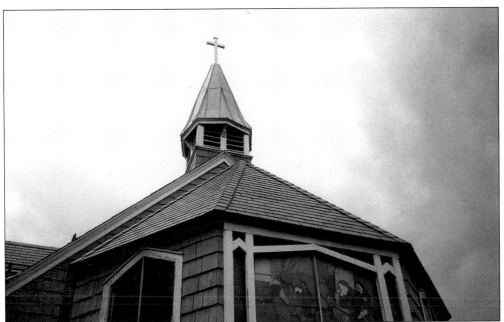

Seen is the Christ Episcopal Church, on Rodgers Boulevard. Originally founded as a church Sunday school on Warren and Third Streets, the church was relocated to its present site in the late 1800s. The first service at the new location was held on November 25, 1883. (Photographs by Karen Floriani.)

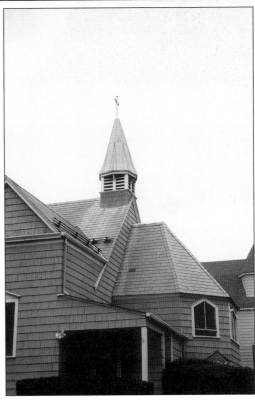

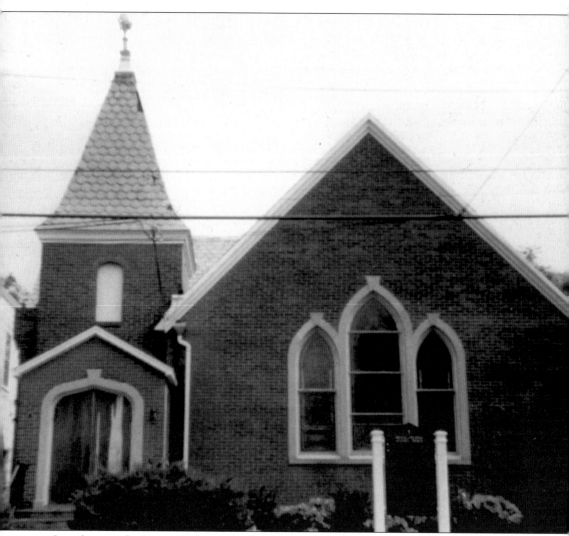

Seen here as the Baptist Tabernacle Church (on Central Avenue), this is now the site of the Spanish Seventh-Day Adventist Church. The congregation originally met in a former paint shop at Warren and Fifth Streets. The present property was purchased in 1898 and dedicated on December 18 of that year.